MUHAMMAD ALI TYNESIDE 1977

Russell Routledge

AMBERLEY

THANKS MUHAMMAD
As you forever told us, there really will never be
another like you champ.

First published 2014

Amberley Publishing
The Hill, Stroud
Gloucestershire, GL5 4EP

www.amberley-books.com

British Library Cataloguing in Publication Data.
A catalogue record for this book is available from the British Library.

ISBN 978 1 4456 2106 7 (print)
ISBN 978 1 4456 2112 8 (ebook)

Typesetting and Origination by Amberley Publishing.
Printed in the UK.

CONTENTS

ACKNOWLEDGEMENTS

I would like to especially thank the past and present editors of the *Shields Gazette*, John Szymanski and Joy Yates, for allowing me the use of quotations and extracts from that time period. Also, thanks to Mirrorpix and NCJ Media/Trinity group for allowing me the use of various quotes from the *Newcastle Chronicle*, *Sunday Sun* and *Journal* and for the use of four photographs. Also thanks go to Brandon Mudditt, son of Fred Mudditt, formerly of Fietscher Fotos of South Shields, and South Tyneside council for the use of their collection of photographs of Ali's visit. Also, a thank you to the staff at Newcastle Central Library, South Shields Library and the Chicago City Public Library for help using their extensive newspaper archives.

Credit also goes to the following: Ron Taylor, the fairground boxing booth owner who gave me some fabulous interviews back in 2005; Nancy Stuenkel, from the *Chicago Sun-Times*, who helped locate and obtain permission for the use of one special photograph; Peter and Dorothy Gillanders and Peter Mortimer, for their help and permission to reprint their poems, and for the interview in 2005; Steve Brock, former senior photographer for Newcastle City Council, who passed permission for the use of city photographs; John Jarrett, for handing me his extensive Muhammad Ali archives.

Extra-special thanks go to Tina Gharavi, from Bridge + Tunnel Productions, who very kindly took me to Las Vegas to personally hand my manuscript to Muhammad and his wife, Lonnie, in 2012. Also to George and Claire from Passion Pictures, who were invaluable in helping me obtain permission for some images for this book. Last, but not least, to Alan Robertson, for giving me permission to use his prized photograph of him alongside the champion. Many thanks also to Paul Ebling and Ali

Enterprises for permission to include images and use the champion's name on the front cover.

Sources of Information

For factual information about parts of Ali's life, reference has been made to the following:

Boxing News
Chicago Daily News
Daily Sketch
Hauser, Thomas, *Muhammad Ali: My Life and Times* (Robson Books: 1996)
Monaghan, Paddy, *Black Crusoe, White Friday* (Satellite Books: 1979)
Shavers, Earnie, *Welcome to the Big Time* (Sports Publishing: 2002)
Shields Gazette
The Chronicle
The Journal

Disclaimer

INTRODUCTION

There are many reasons why Muhammad Ali became arguably the most recognised face and voice of not only all athletes, but also people living around the world. Firstly, it helped that he emerged into a sport and division that had a history of heavyweight champions receiving similar instant recognition to country leaders. American boxers such as Jack Johnson, Jack Dempsey, Joe Louis and Rocky Marciano were just as likely to be talked about and recognised by everyday people as any of the US Presidents in office during their title reigns. In those times, being the king of the ring not only meant possessing 'the richest prize in sport', but also having the status of a Superman figure who could quite easily conquer any living man on earth. Those champions mentioned not only became household names during their respective title reigns, but they also transcended their chosen sport and in many ways represented the times in which they lived.

However, when it became Muhammad Ali's turn to hold onto the same title and status, he became even more widely known than each one of his predecessors. It helped, of course, that his actions, both physical and vocal, were able to reach and be seen by a wider live audience than ever before. Ali's entrance onto the world scene came about at the same time as the early days of commercial satellite technology, where live pictures of sporting events could be bounced around the world. Television contracts would become more important and profitable than sold out arenas, as the live viewing audience became global, rather than confined to a sporting arena. It also didn't harm the boxer's path to becoming arguably the world's most recognisable person when, as a huge betting underdog, 'Kid Clay-Man Ali' shocked the world, not once but twice, after destroying the invincible reputations of both champions, Sonny Liston and George Foreman.

Originally, his approach to fighting split fans worldwide, some liking his occasionally comical way of self-promotion; others not so much. Ali generated fun like the sun generated heat, no more so than when he came up with the idea of linking rhymed poetry with his ring foes. Some, like myself, were spellbound, while others, especially those from previous generations, disliked his mega-hype, mega-publicity treatment of pugilism, which has always been known as the ancient and noble sport of gentlemen. This, combined with his slippery, hands-down fighting style, left many experts with the firm belief that his spell at the top could only be a short and painful one.

More importantly, though, outside the world of boxing, Ali's conversion to Islam and his later controversial stand against the US draft meant stories of the supreme fighting man of his generation were not just confined to boxing. Politics, religion and civil rights became linked to the already outspoken and controversial boxer. Ali eventually became many things to many people around the world and his activities both inside and outside of the boxing ring meant feelings about him, already divided, became compounded.

However, as the years rolled by and times changed, even those from an older generation mostly – but not all – changed their original opinions, respecting his ring achievements and standing up for his principles outside of it. At the time, his refusal to take part in the Vietnam War meant that he stood to lose everything, including his liberty. Ali's mission to become a great boxer inside the ring and a champion outside of it eventually led him to become possibly the most beloved sportsman of all time.

From my teenage years, I joined his many millions of fans around the world and became a great admirer and follower of Muhammad Ali's life and times. Some of those fans may well have been like myself and were first drawn towards the colourful champion not only because of his big fights, but because of his 'big humour'. Ali always possessed a gift for making people laugh and he forever found ways of having fun in a career that was, by nature, tough and sometimes brutal. However, as his boxing career and life progressed, I saw other qualities in Muhammad that would not only capture my imagination, but also my heart.

What fascinated me most about Ali was how he rode through life as the 'king of the world', but never seemed to forget the everyday guy, no matter who or where they were. To illustrate my fascination, this story charts one special occasion when a Tyneside working man's dream was fulfilled by the legendary boxer, and takes a retrospective look at Ali's life during that period.

The year was 1977 and it was already going to be a special one on Tyneside, as both the President of the United States of America and the Queen of England would be visiting the region.

Muhammad Ali was still riding high in his second reign as world heavyweight champion, and the boxer was so much in demand that he was the highest-paid athlete of his time, receiving record-breaking purses fighting the likes of Joe Frazier, George Foreman and Ken Norton between 1971 and 1976.

Johnny Walker worked as a painter and decorator in South Tyneside, but he possessed a burning dream regarding the famous US-based boxer, who was receiving so much world acclaim that sometimes only leaders of countries could afford to finance his title bouts. Johnny Walker somehow wanted to bring Muhammad Ali to the streets of Tyneside and meet the 'Geordie folk', who he believed the champion would quickly warm to.

In 1977, Johnny decided to see if he could turn his dream into reality and travelled to America on an adventure nicknamed 'Mission Impossible'. His objective was to locate Muhammad Ali and ask the champion a simple question: 'Would you come to Tyneside to help boys' clubs and meet the Geordies?' Johnny wanted something else too: he wanted the mega-rich sportsman to come to Newcastle for no personal financial fee.

The timing of Johnny's proposed 'Ali on Tyneside' mission would also be an important one in Ali's own life, as it was shortly before the boxer's electrifying, last-ever successful title defence, and arguably his last-ever great fight, facing the sledgehammer fists of ranking contender Earnie Shavers at New York's Madison Square Garden. Also, in Ali's personal life, he would be married to the stunning Veronica Porsche.

During the boxer's ring career, he would shout and proclaim, 'I am the greatest of all time!' Those words may well be one of Ali's lasting legacy catchphrases, but the following chapters reflect more of a regular one-liner that he would sometimes pen at the end of his many written letters to fans and friends around the world: 'Service to others is the rent we pay for our room in heaven.' Sprinkle Muhammad's unique sense of humour on those few poignant words and many will tell you that this truly reflects the man behind the brash-talking world boxing champion.

Ali's title-winning days are now confined to the history books, but in living by those words, coupled with his unique character, the boxer never lost a more prestigious title: the People's Champion.

A painter and decorator's mission to the States in search of the 'king of boxing' and the events it led to have been recorded here in print to help give credence to Ali's 'People's Champion' title, and to recall times forever etched in the minds of those on Tyneside who met him all those years ago.

Enjoy the story.

1

A SPECIAL YEAR
ON TYNESIDE

During the 1970s, Tyneside looked a far different place from the one we find today. Back then, pit heaps, working coal mines and shipyards were a common sight. Thousands of people were still employed in the region's then major industries, like the armaments factory, Vickers-Armstrong on Scotswood Road, Swan Hunter's on the banks of the Tyne and huge underground mines dotted around the region. However, the '70s was a time of great changes, both economically and socially, and old traditions of following in your father's and grandfather's footsteps in a job 'doon the pit' or into the shipyards 'doon on the banks of the River Tyne' were starting to change.

Thriving communities, such as the one found in Benwell, were also going through dramatic changes as bulldozers flattened many of their old terraced homes, with many people moving into a new style of living – that of high-rise flats or new, out-of-town council estates. At the time, many people were hoping for new industries to invade the region, while others still wanted the old ones to continue. However, two national coal miners' strikes in 1972 and 1974, although eventually bringing better pay and conditions to workers, still didn't halt the decline of an industry that had been responsible for putting food on the table for countless generations of Tyneside families. As each year passed, people on Tyneside welcomed any good news that came along – anything to take their minds off an economic future that was filled with uncertainty.

However, the economic doldrums of the '70s still didn't affect people's humour, as locals were generally seen as both fun-spirited and warm-hearted. Most of these folk would also find themselves with two common bonds that they couldn't shake off even if they wanted to. First, the majority of people born on Tyneside inherited a unique accent, which was certainly different

from others around the country; and second, people from Tyneside were given the nickname 'Geordies', and the name would stick, no matter how far away they travelled.

One theory as to why people from this region are called Geordies comes from the unique type of safety lamp used by the old-time local pitmen while extracting coal from the underground mines in which they worked. The glass-cylindered lamp was devised by a man born only a stone's throw from the River Tyne in 1781, in a village called Wylam, which is about 10 miles west of Newcastle. His name was George Stevenson and he would eventually become one of the great pioneers of the Industrial Revolution. The safety lamp he invented was called the George Stevenson safety lamp, better known as the 'Georgie lamp', and it was primarily used by miners in the North East.

This theory states that the name 'Geordie' derives from the 'Georgie' lamp. There are various other theories out there, but one thing that is a cast-iron certainty is that over time the Geordie name became forever linked to the people of the city made famous by coalmining, Newcastle, and the region it is situated in, Tyneside.

After a week's graft down the pit, or assembling armaments and ships along the banks of the River Tyne, many Geordies looked to the city's football club, Newcastle United, for some welcome relief. The rivalry between them and the team based 15 miles south along the River Wear, Sunderland, is legendary. In 1973, Sunderland caused a massive upset by winning the FA cup, beating the highly favoured Leeds United 1-0, and one year later, in 1974, Newcastle United (The Toon) reached the same Wembley final, only to lose disappointingly to Liverpool 3-0.

Away from the football field, there was one special year during this decade when the Geordies received news that would not only lift their spirits, but also give them great cause for celebration. In 1977, it was planned for the Queen of England and Prince Philip to sail up the River Tyne on the Royal Yacht *Britannia* and spend the day on Tyneside as part of the Silver Jubilee celebrations set for 15 July. Both city and street parties were planned to mark the Queen's twenty-fifth year on the throne.

Additionally, on 6 May of the same year, locals would welcome the unique sight of the newly installed 39th President of the United States, Jimmy Carter, flying into Newcastle on the presidential jet, Air Force One. It was on 20 January 1977 that Carter first took office, and his first overseas visit as President was to London and the North East of England. He came to the UK for an International Economic Summit meeting, joining with five other nations' leaders, including UK Prime

Minister James Callaghan, in London to discuss how to solve the many problems facing the world.

During Jimmy Carter's whistle-stop visit to the region, he appeared alongside James Callaghan and Newcastle Lord Mayor Cllr Hugh White before 20,000 cheering people outside the city's Civic Centre. The Lord Mayor officially welcomed the US President on behalf of the people of Tyneside and made him an honorary Freeman of the city.

Carter became an instant hit with the cheering crowds when he welcomed everybody with a famous Newcastle United football chant, 'Howay the Lads', and the President spoke of 'the special friendship and historical ties of kinship between the peoples of the United States and Great Britain'. That morning, the Lord Mayor also spoke about the people of Newcastle and those from Carter's home city of Atlanta in Georgia taking part in an international friendship and cultural exchange programme called the 'Friendship Force', which was personally supported by the visiting US President.

Although the Friendship Force was not a part of the new President's official duties, the idea was still introduced at a US White House gathering in March of that year. Surprisingly, Newcastle upon Tyne and Atlanta were to take part in the first-ever international friendship programme. The Friendship Force was and still is meant to help promote world peace through ordinary people in different parts of the world, offering a hand of friendship by way of living in each other's homes and building up personal relationships.

The Geordies and Georgians were invited to be hosts or ambassadors on this transatlantic exchange programme, and people would be matched according to similar jobs and interests. It was then arranged for about 381 people from Newcastle to fly on a specially priced package that included a Pan American jumbo jet flight to Atlanta for a ten-day visit starting on American Independence Day, 4 July 1977. With the time difference between the UK and US, the Geordies would still arrive in Atlanta on this celebratory day and to the joyous welcome of brass bands, city dignitaries and famous southern state hospitality.

The same Pan American aircraft that transported them was used to fly a similar number of Georgians over to Newcastle upon Tyne, where they would meet their Geordie hosts the following morning on 5 July. All participants were called 'Ambassadors of Peace'. The founder of the Friendship Force was a gentleman from President Carter's home city of Atlanta called Revd Wayne Smith. He was a Presbyterian minister who had a vision of creating a better world by bringing people together

internationally. His plan was to create a global network of people exchanging hands of friendship and experiencing first-hand each other's lives and cultures.

I was particularly looking forward to the inaugural international exchange, as I worked for the department that co-ordinated the Tyneside side of the programme – this being the city's Information & Publicity department, headed by Director Alan Redhead. Over 1,500 application forms from people who wanted to take part arrived in our office, where the selection process began by interviewing those who were best matched with US citizens that wanted to take part. The scheme was primarily made up of Geordies, but was open to anyone in the North East.

The US President's wife, First Lady Rosalynn Carter, was also involved in the Friendship Force, being the honorary chairwoman, and her mother, Mrs Allie Smith, took part by joining the other chosen Ambassadors of Peace from Atlanta and boarding the same jet leaving for Newcastle upon Tyne on 4 July. The US contingent would arrive for a ten-day stay in Newcastle on 5 July (UK time) until 15 July. The Geordie/Georgia exchange programme would also just coincide with the Queen's Silver Jubilee visit to Tyneside on 15 July, this being the last day on Tyneside for the citizens of Atlanta. 'Geordieland' had never seen anything like it before: both the new President of the United States and the Queen of England on Tyneside in the same year.

Ironically, during the evening of Carter's visit on Friday 6 May 1977, the big story going around in local amateur boxing was that 6-foot 5-inch-tall heavyweight George Scott, boxing out of Jarrow Perth Green amateur boxing club and formerly out of West End boys' club, took part in the 90th ABA boxing finals at the Empire Pool, Wembley. He narrowly failed to win a prestigious ABA heavyweight boxing title, losing a points verdict to Barnstable's talented Glen Adair.

A MAN WITH A DREAM

The man grabbing the news internationally in professional boxing during 1977 was Muhammad Ali. On 17 January of that year, he turned thirty-five years old and was 'king of the boxing hill', still holding onto the world heavyweight title he had won three years earlier. The professional pugilist had dominated the sport for years, after first capturing the title in 1964 and regaining it a long ten years later in 1974.

Almost from the moment he rose to international prominence in the early 1960s, Ali had become the Pied Piper of boxing. His personality, coupled with his rhyming poems dedicated to his falling opponents, attracted much hype and publicity, and whether people loved or loathed him, they couldn't ignore, stop, or change a young man who did things his way, both in and out of the ring.

Cassius Clay first arrived in London in 1963 as a twenty-one-year-old fistic contender when he faced Briton Henry Cooper at Wembley Stadium, and his antics not only attracted a mass of attention and publicity, but also much derision, dislike and laughter. However, most of the bad feeling had dissipated by the time he next arrived in 1966, this time as world heavyweight champion. By then, Ali even found that many of the patrons in the UK who had previously derided him had become, or were becoming, among his most ardent supporters in the world.

Well before the '70s reached their halfway point, Ali had marched through every obstacle imaginable: the US Government, Joe Frazier's crunching left hook, and a broken jaw handed to him by the gloved mitt of ex-marine Ken Norton. However, he carried on undeterred and eventually upset practically every oddsmaker in the world by regaining the world heavyweight title against the previously unbeaten 'Mr Devastation Incorporated', George Foreman.

Even before this win, which many said was his 'greatest', Ali was much loved and even idolised by masses of people around the globe, and it was no different in the UK. People would travel from miles around just to catch a glimpse of the famous boxer who, by then, was talked about as being in the realms of a living legend.

In December 1974, I was one of those very fans who travelled the miles just to catch a glimpse of Ali. I was sixteen years old and travelled 300 miles from Newcastle to London to see for myself, in person, the king of boxing. Ali had stopped off in London on his way back to the States, after returning from a Presidential invitation at the location of the 'Rumble in the Jungle' against Foreman in Kinshasa, Zaire, Africa, which took place only six weeks previously.

My opportunity to see him came about when he made an appearance at London's Royal Albert Hall, to see a likely future ring opponent, Briton Joe Bugner. Big Joe was fighting a fellow called Alberto Lovell that third night in December, but many in the packed arena were like myself and had only turned up to see, in person, the new heavyweight champion, Muhammad Ali.

Before Bugner's bout, Ali stood centre ring and was introduced to the crowd, but while doing so he made the arena echo with laughter as he started to playfully size up another boxer who stood alongside him. That boxer was fellow world champion John Conteh, who had captured the WBC light heavyweight title only a couple of months previously in October, the very same month that Ali performed his demolition job on Foreman. Conteh received a fabulous ovation that night, but the spotlight and the gaze of a majority of the fans remained on Muhammad, even after he left the ring to watch the main bout of the evening from the ringside.

The big fight didn't amount to much though and, amid much booing and foot stamping throughout, the referee thankfully stopped Big Joe's opponent from taking any more punishment in only the second round. Ali, sensing the crowd's disappointment, took everyone by surprise and stole the show, by jumping out of his ringside seat, climbing up onto the ring apron and doing his famous routine, tearing off his expensive-looking jacket and 'hamming' it up with Bugner. From the back of the hall, it may have looked like the champion was in a serious mood as he slung punches in Bugner's direction and flexed his muscles, but Ali was only joking, and his one-man show instantly became the main event of the night.

Muhammad caused both mayhem and excitement that night and I stood, wide-eyed, near to where the champion was holding court, witnessing for the first time in person the amazing effect he had on everyone. His presence seemed to shoot a bolt of electricity through the hall and the uproar and

chaos inspired by his antics continued right up to his departure. The next day I made the journey back to Newcastle, anxiously wanting to get back to school to tell my buddies about the time I saw the Greatest in the flesh.

Another local fellow called Johnny Walker had also travelled the long road from Tyneside to London to catch a glimpse of the world heavyweight champion. However, his trip was eight years previous to mine, back in August 1966, shortly before Ali, who was then only in his second full year as the new champion, defended his world title for the fifth time against Britain's Brian London, at the capital's Earls Court arena.

One day before the big fight, Johnny, accompanied by his young son David, went to the London hotel where the heavyweight champion was staying and, with the help of a newspaper called the *Daily Sketch*, the story of young David's long journey to meet the Greatest soon reached the ears of his trainer, Angelo Dundee.

Johnny and his son's hotel visit would occur only six days after Ali had sat as a spectator at the same Wembley Stadium where Henry Cooper famously decked him three years previously in 1963 to watch the England football squad win the 1966 World Cup against Germany. Johnny and his son's special day would also happen around the same time as Ali visited Lee Marvin and the rest of the famous cast of actors taking part in a movie being shot in Hertfordshire called *The Dirty Dozen*.

When father and son arrived at the hotel, the world champion was upstairs resting in his suite, but Angelo Dundee insisted that the youngster's 300-mile trek should be rewarded with a prized personal meeting with the boxer and he took father and son up to Ali's room.

When they walked in, the champion was lying in bed, but he still greeted the duo, and photographs were taken of boy David squaring up to the famous boxer. They chatted for a while, with Muhammad asking David his prediction of his fight with London, and fight fan David predicting an Ali win.

The next day, on 6 August 1966, the day of the World Heavyweight Championship bout, Ali's face was, unsurprisingly, plastered over the front page of the now defunct national tabloid newspaper, the *Daily Sketch*. However, what was surprising was that it wasn't his opponent Brian London's photograph that accompanied the champion's, but that of Johnny's son, David. The headline read 'David and Goliath', and the story of young David's meeting with Ali was accompanied by a picture showing boy David placing a playful punch on the famous 'Louisville Lip', while the champion lay flat (in bed), with fists raised.

Johnny and David's meeting with Ali that day, and the front-page newspaper coverage that followed the next morning, may well have been

more memorable for them than the fisticuffs that followed later that night. One thing to be said was that their hotel chat with Ali probably lasted longer than Brian's fighting time in the ring, as the 'Blackpool Rock' was unfortunately KO'd in less than nine minutes.

The 1966 front-page picture of 'David and Goliath' would certainly have surprised a lot of people back home on Tyneside, and the memory was something the Walker family could cherish forever. However, Johnny would go on to harbour a much more extravagant dream than simply getting a prized personal hotel meeting with the famous boxer. His long-held ambition, which was dismissed as impossible by practically everyone on Tyneside, was to somehow bring Muhammad Ali, the Greatest, to the streets of Geordieland.

By the turn of 1977, Johnny Walker was forty-three years old and working as a painter and decorator. He lived with his wife Jean, two daughters, Wendy and Jo-Ann, and son David in a village called Whitburn, not far from the seaside town of South Shields in South Tyneside. During the 1950s, Johnny himself showed more than a willing keenness to get involved in sport, possessing a natural talent for both boxing and football. It was this talent, combined with his unwavering dedication, that led him to a career as a professional footballer and to compete as an amateur middleweight. During his Army days, he spent some time in the States and even won some prestigious Golden Gloves titles. Unfortunately, his football career was cut short due to diabetes, but his interest remained, and his love of boxing not only kept him closely linked with the local amateur boxing scene, but also the pro game.

During former world boxing champion John Conteh's glory days, Johnny held the distinction of being secretary of a North East based John Conteh fan club, which was based at the Legion social club in South Shields. At Conteh's UK fights, including his world title win at Wembley against Jorge Ahumada in 1974, fans would board a bus, with Conteh's name emblazed across it, decked out in banners, and meet up with fellow fans to travel the miles in support of the extremely talented boxer at his fights.

Johnny Walker also formed a friendship with the champion boxer and his link was strengthened when, as the family would proudly tell, 'King' Conteh became godfather to their youngest daughter, Jo-Ann. Also, in addition to being involved in Conteh's fan club, Johnny remained keenly interested in the local boxing scene and involved himself in local charity activities.

Johnny's links and opportunities to rub shoulders with boxing royalty like John Conteh meant that he had good contacts to approach for advice on his chances of bringing the Greatest to the region. During Conteh's career, there had been constant on-and-off speculation of John being a possible opponent of Ali. The speculation continued even after Conteh, on the advice of

Muhammad himself, because of his lack of bulk and size, dropped out of the heavyweight division to compete with the world's best light heavyweights.

With Johnny's boxing background, friendships he made in the sport, the knowledge he gained being around the fight game and especially the type of characters that it attracted, he would have been well aware of the psychology of most boxers: this being that, although pugilists had the temperaments of lions while in the ring, most possessed softer hearts when the gloves were unlaced. Muhammad Ali was no exception and Johnny would have been well aware of the champion's kind spirit and generous nature. He believed that if he could only somehow get another personal meeting with Ali and explain in his own words what it would mean to local, working folk for the boxer to come and meet them, then, he felt, Muhammad wouldn't hesitate. Getting the opportunity to convey his feelings personally to the world champion was always going to be his biggest hurdle, as by 1977 he was arguably the most famous and recognised person on the planet, attracting millions of dollars for one night's work. However, Johnny's time with local boys' clubs, his links with Conteh and other friends he made while involved in the boxing scene, meant thoughts of 'what could be, if only...' were never far from his mind.

Johnny would have known that he could never use money as an incentive to tempt the champion over to Tyneside, as in 1977 there probably wasn't enough spare cash in the whole of Geordieland to pay Ali the wages he was accustomed to. In his last paid fight in September 1976, against Ken Norton in New York City, Ali received a whopping $6 million. Big figures always went with the territory of a heavyweight champion, but he was attracting interest and dollars on a scale that was breaking all previous records. Big bucks accompanied Ali's personal appearances and endorsements too, so offering the champion the fees that he was used to couldn't be an option.

However, Johnny was a working guy who helped local 'kid boxers' and was involved with various local charities. His dream was not just for Ali to be tempted over to meet the Geordies, but for him to come over to help the boys' clubs that he was involved with. His close involvement with the youth organisations gave him an insight into their plight and he could see that they were all cash starved, with the facilities the kids used being pretty basic to say the least. He was well aware of Ali's generosity when it came to causes he believed in, as the champion's charitable side was almost as legendary as his big fights. There had been fairly recent stories in the States of Muhammad writing a six-figure cheque on the spot after watching a retirement home being threatened with closure, and there were countless other stories in the press about him partaking in charitable events, even in boxing exhibitions to raise money for different charities.

Johnny firmly believed that if Ali somehow found out about the children's plight in the North East of England, then there was a splendid chance of him coming to help those very kids that Johnny saw turning up each night in the local gyms with borrowed gym shoes and tattered clothing. At the same time, he could meet everyone on Tyneside. In Johnny's mind, the only obstacle was finding the opportunity to personally ask him.

One thing was certain: with a touch of bravado and a little help from a newspaper and a man of influence (Angelo Dundee), Johnny had found himself sitting alongside Ali in his private suite in 1966, so maybe, with a little help and luck, history could one day repeat itself.

A couple of years earlier, Johnny travelled with a sports writer who worked for a local newspaper called the *Shields Gazette*. The writer, Dick Kirkup, had ridden with the John Conteh fan club on the 'Conteh coach' to John's title fight against Lonnie Bennett at Wembley in March 1975. On the way, Johnny repeated something that he had told Dick years earlier: that one day he really was going to bring Muhammad Ali to Tyneside to help all the local boys' clubs. Johnny may have sounded cocksure that he would make it happen, but it's more likely that his words fell on deaf ears, as his idea was thought out of the bounds of reality. A past meeting with Ali in a hotel room was one thing, but bringing the same man to the streets of Tyneside was something else. No one seriously believed that a working man, with no serious funds, could persuade the highest-paid sportsman in the world to come to somewhere he had probably never even heard of before.

Johnny also told the sports writer something else: he said that, if given the opportunity, he could not only convince Ali to come over, but could persuade him to come without being paid a fee. Johnny remained optimistic, but most people he mentioned his dream to told him what he didn't want to hear; that was, in reality, without huge sums of money to pay the world champion some kind of 'grand fee', his more than ambitious idea could only remain a wistful dream.

Up until 1977, the only link Muhammad Ali had with walking the streets of Tyneside came by way of a local clairvoyant called Mary Darling. Five years earlier, in 1972, she scribbled down her future predictions. Incredibly, she predicted that Muhammad Ali, the Greatest, would indeed turn up on Tyneside sometime in the future. She could hardly believe her own forecast at the time, as she wrote next to her notes, 'Is this some kind of joke?' The 1972 prediction was eventually put to the back of her mind but, unbeknown to her, Johnny Walker was the person that dreamed of turning her mystic thoughts into reality. And 1977 was going to be the year he would try to achieve it.

The timing of the Queen of England's and the President of the United States' planned visits to Tyneside certainly wouldn't harm his chances of enticing Muhammad Ali to come, but youth organisations were something close to Ali's heart and this would be the crux of him accepting any invitation.

Johnny's enthusiasm may well have been shared by his wife, Jean, as there was something inspiring about attempting to search out personal ambitions, but his grandiose idea sounded more like a pipe-dream than something that could realistically be achieved. She was convinced he couldn't bring Ali to Tyneside and she wasn't the only one. People he mentioned his idea to always said the same thing: 'Yeah, ambitious thinking, but it's impossible. Why would Muhammad Ali come here?'

However, the local boys' clubs needed money to improve their facilities and, despite scepticism from almost every quarter, Johnny remained optimistic of coming up with a plan to attach to his ambitious dream.

Between 1960 and 1977, Tyneside had been visited by no fewer than three past undisputed heavyweight boxing champions. The huge Primo Carnera, who won the title in 1933, first turned up in Newcastle five years after appearing alongside Newcastle-born actor/wrestler Joe Robinson in a 1955 movie called *A Kid For Two Farthings*. Carnera's arrival in Newcastle came long after his boxing days were over when he, having later taken up wrestling as a profession, turned up for two grappling assignments at the now long-demolished boxing and wrestling arena called the New St James' Hall in 1960.

Another champion, but one who was still wearing his world crown at the time, also visited the North's premier boxing stadium back on 16 September 1963. The world heavyweight champion had arrived the previous day from Ulster in Northern Ireland as part of a European boxing exhibition tour.

In Newcastle, the champion approached the place of his exhibition bout slightly differently, riding atop a white horse called Prince all the way from his hotel on Neville Street up to the hall, which was then situated adjacent (where St James Metro station stands today in Gallowgate) to the football stadium with the same name (St James' Park). The rider was none other than the then reigning heavyweight champion, Sonny Liston. Thousands of people lined the streets to see the fearsome fighter who many were calling 'invincible' at the time. When Sonny dismounted at St James' Hall, vast crowds turned up at the turnstiles, paying between 12s 6d and £3 3s to watch a full bill of boxing, which also included popular West Hartlepool bantamweight George Bowes, who knocked out Johnny Bean in five rounds, and welterweight Tony Smith from Bootle, Liverpool, who lost by a disqualification in the fourth round to Wilson Harris.

When it was Sonny's time to perform in the packed 4,000-capacity hall, the champion boxed three sparring rounds against his spar mate and travelling companion, light heavyweight Foneda Cox, and performed a skipping routine to his favourite song, 'Night Train'. The 1s programme told how fans would see more action in one night than fans in America saw in his last three professional fights, stretching all the way back to 1961.

Only two months before Liston's 'Toon Times', Sonny demolished Floyd Patterson's plans of becoming the first-ever three-time boxing champion by destroying him in two minutes and nine seconds in Las Vegas on 22 July. He had already beaten Floyd in similar fashion one year previously, in Chicago on 25 September 1962, taking Floyd's world title four seconds earlier than the Las Vegas bout, in two minutes and five seconds.

Sonny's next title fight would take place six months after departing from Newcastle, and no one would have predicted or believed at that time that it would be Liston's last-ever fight as world champion. The bout would take place in Miami Beach Convention Centre, Miami, Florida, on 25 February 1964. His opponent would be a brash, young, non-stop-talking kid who had won an Olympic gold medal in the light heavyweight division at the 1960 Rome Olympics. Although Sonny's next opponent was undefeated and called himself the biggest thing to ever come out of America, he had recently been knocked off his feet and, some said, nearly knocked out by Britain's Henry Cooper only a few months earlier at Wembley Stadium in June 1963.

The twenty-one-year-old fighter's name was Cassius Marcellus Clay, later to be called Muhammad Ali. Young Clay picked himself off the floor that evening and won the bout in the next round. Cassius's shock fourth-round knockdown didn't dampen his enthusiasm or confidence against Liston, but the major consensus among boxing writers and experts around the globe was that if the two met in the ring, Liston would quickly obliterate the young man that was then calling himself the 'Louisville Lip'.

At the time of Liston's Newcastle visit, there were still a lot of negotiations taking place behind the scenes before a Liston *v.* Clay bout was certain, but that didn't stop the champion having a few choice words to say about his next likely 'easy' ring opponent, as he announced to the crowd that Clay would be no different than his previous hapless opponents. He said that once he caught up with 'mighty-mouth' and handed him some of his 'medicine' the fight would be over. The 'medicine' Sonny detailed was his gloved fist being forced down Clay's throat. He said he only hoped there would be a doctor sitting ringside to remove his lodged fist afterwards. Liston was more than keen to shut the brash, loud kid up, who had been agitating him with his publicity grabbing antics, calling him, among other things, the 'big ugly bear'.

At the time of Liston's sparring exhibition in Newcastle in 1963, it looked like Sonny would still be champion until 1983, or for as long as he pleased anyway. The word 'indestructible' had been attached to his already formidable reputation, as opponents appeared intimidated, even scared, when venturing up the ring steps to face the fearsome, huge-fisted fighter. Clay was generating much laughter and making plenty of noise, but most felt it would be no different when it was his turn to face Mr Liston.

In September 1966, former ring great Joe Louis caused quite a stir in Piccadilly, London, when he made a three-week, well-publicised gaming and cabaret club appearance at a city nightspot called the Pigalle Sporting Club. What many didn't know was that the 'Brown Bomber' actually made his first UK cabaret appearance in Newcastle upon Tyne exactly one year earlier, on 1 September 1965. A deal had been made the previous year to bring Louis to the UK, and his appearance at the Newcastle nightspot called La Dolce Vita came by way of London booking agent and one of the three owner brothers of the city-centre club, forty-two-year-old David Levey. The club, which first opened its doors during the year of Liston's visit (1963), no longer exists, but it was then situated on Low Friar Street, a back lane running off Newgate Street.

'Brown Bomber' Joe Louis was paid a then hefty £2,000 for his four nightly appearances (1 September – 4 September 1965). During his 'Toon' stay, Louis said earning money from cabaret was a lot easier and better than fighting for it. Any fans or inquisitive club-goers who wanted to see the former champion were charged 10s and £1 at the door.

Johnny was well aware that these former ring greats had visited the region, and their time in the city could be used as added incentive to lure Ali to Tyneside. To help further turn his thoughts into reality, Johnny also approached one knowledgeable person who would give him a realistic idea of his chances and the best way to get his idea off the ground. This was Andy Smith, manager of Dave 'Boy' Green and heavyweight Joe Bugner (Bugner would temporarily retire after losing to contender Ron Lyle in March 1977).

Andy Smith had been in Joe's corner when Ali surprisingly turned up in the Las Vegas Convention Centre ring in a multi-jewelled ring robe given to him by Elvis Presley before their bout in 1973, and also when the two fighters met again in Kuala Lumpur for the world championship fight in 1975. Andy had even paid Ali some serious dollars during his boxing exile in early 1970 in Miami for him to spar a few rounds with his young prodigy.

Andy was personally and professionally known by Ali and he gave Johnny possibly the best advice of all; although, unfortunately, money

would play a part in helping him make his dream come true. He told Johnny that contacting Ali by mail or sending telegrams asking him to come to Tyneside would probably never be successful. Andy told Johnny that his best chance would be for him to locate Ali himself and ask him personally, straight from the heart, as it were, if he would come – that would be the only way, he felt, that Ali would realistically travel to the North East.

The crux was that Muhammad Ali lived in the USA and, in 1977, very few people on Tyneside had the finances to chase likely unachievable dreams to the other side of the world. Flights alone came in at a very steep price, as the bargain deals we can find in today's travel market just weren't available then. However, Johnny's involvement in the local amateur boxing scene meant that he had formed friendships and contacts with people who did have access to such funds and who shared his interest in boxing. They just might take an interest in his 'Ali on Tyneside' idea.

Jimmy Stanley was one such person. He was a fellow long-time boxing fan who had sponsored many local amateur boxing shows. Jimmy also ran a successful scrap metal business in Swalwell, Gateshead. Late in 1975, Johnny first mentioned to Jimmy his dream of bringing Muhammad Ali to the North East, and they both talked about the possibilities for well over a year. Then, one Sunday night, a knock at the door of Jimmy Stanley's home found Johnny Walker on the doorstep with a direct question. He wanted to know if Jimmy would be willing to pay his costly airfare to the States to try to locate the world heavyweight champion, so that he could personally invite him to Tyneside to help the region's youngsters. Johnny asked Jimmy to back him with not only money, but also confidence, because he was convinced that, if he got the chance to meet Ali, his invitation wouldn't be refused.

The region's boys' clubs desperately needed help and if Ali heard about their economic plight, he was sure he would want to come over and help. Johnny's talk was convincing enough for Jimmy to agree to part with the money to back his idea, but it was a mighty task and both Jimmy and his family were far from 100 per cent confident that Johnny could return home from the States bringing Ali along with him.

In early 1977, another person became involved and partnered Jimmy to front the much needed finance, backing Johnny's Ali dream all the way. His name was Larry Shinwell. Larry had more than a few bob to his name, being a prominent building contractor and earning his money from textiles and property. They banded together and decided that they would give it their best shot and support Johnny all the way to see if he really could persuade the Greatest to come to Geordieland.

Johnny's long-held ambitions really gathered momentum, and ideas were replaced with a firm plan of action. The beginnings of a committee of advisors and helpers were formed. Johnny, Larry and Jimmy were joined by Clive McKeag (chairman) who was a local leading solicitor, and a QC, Wilfred Steer. The treasurer appointed was a local bank manager, Mr A. E. Clark, and the official press officer would be the *Shields Gazette* sports reporter, Dick Kirkup. The committee would also be joined by Michael Cookson, who was the chairman of the Northumberland Association of Boys' Clubs (NABC).

Singing star Frankie Vaughn, internationally known for the song 'Give Me the Moonlight' and many other hits, was already on the executive board of the NABC and raised thousands of pounds each year for charity. As the NABC chairman, Michael Cookson was part of the 'Ali on Tyneside' committee. It didn't take long before Frankie heard the magic words 'charity', 'boys' clubs' and 'Muhammad Ali', and when he did, he wanted to get involved.

Boxing and boys' clubs always brought many warm and pleasant memories back to Frankie as he had been a boy boxer himself. As a youngster he was a keen member of the Lancaster boys' club, and it was here that he first laced on the gloves and learned the rudiments of pugilism. He found that he was so good at it that he even represented the boys' club team and once reached the final of the Lancaster boys' championships.

Even though his aim then was to one day become a successful boxer, it all changed when he attended the Lancaster College of Art, where his attention was diverted from boxing to song and stage. Eventually, Frankie became an extremely successful singer and was known throughout the world for his talents in show business. Success brought him much wealth, but it didn't bring a short memory along with it, and he never forgot his time with the boys' clubs. Frankie not only got involved with the NABC in England, but would also ensure he donated a monetary sum of each song he released to the organisation. His tireless work and kind-hearted donations to youth organisations and endless other charities was officially recognised in 1965, when he was awarded an OBE.

In 1973, Frankie added a touch of luck to another North East dream, when he sang the yearly traditional prematch hymn 'Abide with Me' just before Sunderland Football Club trounced Leeds in that FA Cup final. Four years later, it was hoped he could repeat this feat, but this time with a Geordie's dream.

Frankie certainly had all the necessary credentials to at least help Johnny move a few steps closer to that dream. His international reputation and strong commitment to boys' club, would not only add credibility to their

plans, but also hopefully a large amount of luck to the US adventure that they had all ironically labelled 'Mission Impossible'.

Everyone on the committee agreed that the best time to try to convince Ali to come would be to coincide with the Queen's Jubilee visit later that year in July 1977. Then, the Queen of England and the king of boxing could be on Tyneside at the same time.

The committee members then went about contacting leading people in such diverse fields as sport and politics, and asked them to back their venture with written words of support. It wasn't long before they received a small avalanche of letters from all around the country. The plan was for Johnny to take these influential letters with him to America. Ali could then see for himself that it wasn't just Johnny Walker but the whole country that was seeking his aid for the region's kids' clubs. In addition, Johnny could also use the 'Sonny Liston and Joe Louis once in Newcastle' stories to trigger Ali's imagination and, if that didn't work, he still had the 'King and Queen' on Tyneside idea as something that might persuade even the Greatest to accept.

The letters of support started piling up: one coming from the Lord Lieutenant of Tyne and Wear, Sir James Steel, who wrote,

'I heartily support your suggestion to invite the world-renowned Muhammad Ali to be your guest of honour. His presence will enormously increase the popularity of the international tournament of boxing and will ensure financial success of the event to the lasting benefit of the youth of the region.'

Other letters came from the then Mayor of South Tyneside, Cllr Mrs Lillian Jordison, Lord Mayor of Newcastle Cllr Hugh White, and Cllr J. E. Hardy, Mayor of Gateshead Metropolitan Borough Council, who said,

'I am sure the North East of England will certainly rise to the occasion if this visit can be arranged. I do earnestly hope that you will be successful in your efforts and that he will be able to accept your invitation.'

In the world of boxing, Andy Smith sent a letter, along with letters from John Conteh and international boxing promoter Harry Levene.

Johnny's idea even started to circulate the Houses of Parliament, when the MP for South Shields, Mr Arthur Blenkinsop, mentioned Johnny's venture to the Minister of Sport and Recreation, Dennis Howell.

1977: ALI'S BUSY YEAR

The people who were supporting Johnny's idea certainly had credibility, but there was another major factor that had to be considered. Even if Johnny managed to track the champion down and received an opportunity to personally tell him all about the plight of kids' clubs back home, and even if he managed to get Ali hooked onto the 'King, Queen, Liston and Louis on Tyneside' idea, it was probable that the champion wouldn't have the time to do it. 1977 was not only going to be another busy year for Ali the boxer, but also for Ali the budding movie star, and his personal life would also be going through some major changes.

Although Ali announced his boxing retirement shortly after defeating Ken Norton in 1976, intending to spend more time spreading the word of Islam throughout the world, it was found before the year was out that both the WBA and WBC had been notified by the boxer's management that he intended to continue. Whatever the motives for Ali continuing in the boxing world, one thing was certain: defending the world heavyweight title for another year would bring in some fabulous financial rewards.

Don King had received interest from a foreign source that was prepared to fork out as much as $16 million to host an Ali *v*. Foreman II super-bout. Madison Square Garden also came into the picture when they declared that they already had Ali under a $2.5-million contract to face contender Duane Bobick, but at a hearing in Chicago in March 1977, Ali reasoned that his announced retirement in 1976 should free him of the contract.

At the 1976 WBC annual conference, it was stated that if Muhammad remained their champion, he would be given the stipulated time limit from his last defence against Ken Norton to face George Foreman, but he would be allowed to fight one opponent of his choice within that time. However, all hopes of Don King promoting 'Super Fight II' between Ali and Foreman

would eventually be scrapped after 'Big' George surprisingly lost to Jimmy Young on 17 March 1977. Slick boxer Young was the same contender that took Ali to within a whisker of his title in April 1976 and the very same boxer who came to England between 1973 and 1974 and beat British hopes Les Stevens and Richard Dunn. He had also fought a tough, drawn contest with Liverpool-born banger Billy Aird in London.

Foreman faced Young at the Coliseo Roberto Clemente in San Juan, Puerto Rico, and it was thought that Young would be of little risk to the proposed $16-million Ali/Foreman II fight. Young had already lost by a quick stoppage to another big puncher on 19 February 1973. His opponent that night was Earnie Shavers, and Young was stopped by his mighty fists in front of his home-town supporters at the Spectrum, Philadelphia, Pennsylvania (Young would later box a draw with Shavers).

Jimmy Young ended up giving Foreman a miserable night, as George was floored and soundly beaten on points in a massive upset. After the fight, Foreman said he'd had a spiritual experience in his dressing room, believing God had sent him a message and wanted him to serve as a Christian minister. This he did, and it was another ten years before he laced on a pair of boxing gloves for pay again.

One businessman from California also made claims of having the champion signed up for his next fight. He stated in a press conference in March 1977 that Ali would 'probably' face the winner of the upcoming Ken Norton *v.* Duane Bobick fight set for 11 May, and would receive $12 million for what would likely be the last fight of his career.

There was much talk and publicity surrounding real competition fights for the champion's now revised '1977 last year in boxing', but it wasn't only fighting that would be filling his agenda. Outside of the ring, Ali was about to star in a soon-to-be-released movie portraying his turbulent life and career called *The Greatest*. The film would be released in May 1977 and it was based on the book of the same name by Richard Durham. The movie would be shown and distributed by Columbia Pictures and there would be many commitments to be honoured on the film's national and international promotional programme.

On top this, there was also Muhammad's personal life: he was planning to be married for the third time. His bride would be a young, beautiful lady he met during the build-up to the George Foreman fight, Veronica Porsche. In 1974, she was chosen as one of four lucky girls out of seventy other hopefuls to help promote the African 'Rumble in the Jungle'.

So Johnny getting a personal meeting and then convincing the champion to travel on a charitable mission to some place on the other side of the

world was only half the battle. For Muhammad Ali to come to Tyneside, it would also have fit into an agenda that was already fully booked with engagements he couldn't and wouldn't want to get out of.

It was understandable that practically everyone on Tyneside who heard of Johnny's ambition couldn't see it ever materialising, with most dismissing his idea before the words 'Muhammad Ali' had even left his mouth. However, the professional committee supporting Johnny knew that it was a 'now or never' plan. The Queen was coming and they wanted to try everything possible to make the 'king' come too. The influential letters that they'd collected would be of help to Johnny but, more importantly, they knew that Johnny had the enthusiasm, personality, commitment and bottle to knock on the world heavyweight champion's door and ask him politely if he wouldn't mind popping over to 'The Toon' to help some kids. They also knew he possessed the genuine sincerity and character necessary to convince even a celebrity like Ali to grant him his wildest wish.

Those on the committee knew the world champion owned a mansion in Chicago, but Johnny would be travelling without any personal or official invitation. Even if they knew his exact home address, the chances were that, without Muhammad having previous contact or knowledge about Johnny travelling over, he wouldn't be at home, as the Chicago mansion was only one of Ali's many residences. Muhammad also spent time on a farm he owned across the State lines in Michigan and at a log cabin training facility, over 800 miles away from Chicago in Deer Lake, Pennsylvania. Also, unfortunately for Johnny and his backers, the champion was well known for not staying in one place for too long.

Johnny's attempt to achieve his grandiose ambition would be a 'one-off mission' as there was no finances for a second flight, but 'Geordie John' wasn't about to scupper his once-in-a-lifetime opportunity. He collected the letters of support, photographs of the North East, his family and regional boxing clubs, and prepared for his unique US adventure. Although disbelievers stretched far and wide across the Geordie nation, there were a few factors going in Johnny's favour. First, of course, was Ali's heartfelt desire to help youth organisations. He knew he was a role model to youngsters from all cultures and ethnicities around the world. If word reached his ears of the plight of some of them back in Tyneside and he felt he could help, there would be more than a good chance that he would do so.

Secondly, those close to the boxer knew that one possible way of getting him switched onto an idea was for people to tell him that to do a certain thing was unthinkable, crazy or even impossible to attempt. The word 'impossible' seemed to be something that instilled motivation in the

champion boxer during those times. Johnny would be leaving the UK on 'Mission Impossible' and those two chosen words might sit well in the imagination of Muhammad Ali.

Thirdly, Muhammad was known to have an affinity with people who had the odds stacked against them. He spent his career and life defying the odds. The majority of people said he couldn't beat Sonny Liston. The same people said it was 'impossible' to defy the US government. They assured him that he couldn't come back after losing to Frazier in 1971 and they cried out in unison that he should definitely retire after losing to Norton in 1973. Ali didn't listen to the doubters and brushed aside the claims of impossibility and ended up proving everyone wrong. Johnny similarly refused to listen to his doubters and prepared for his own impossible mission.

What most of the doubters didn't realise was that the more people who were predicting that Johnny Walker, a painter and decorator from South Shields, could never in a million years bring the world's highest-paid sportsman to Newcastle, the more likely it was that Muhammad might consider the idea – that is, if he ever got to meet him.

In Tyneside, however, the majority of people were disbelievers – myself included. We all said he couldn't do it.

'MISSION IMPOSSIBLE'

By March 1977, the plan was in place. Johnny would fly to Chicago, while at the same time, Dick Kirkup, the sports reporter for the *Shields Gazette* and official press officer for the committee, would contact the press in Chicago and inform them of Johnny's imminent arrival. He would relay the story that an Englishman was coming all the way from somewhere called Geordieland in Northern England to personally ask Muhammad Ali for his much needed help to raise funds for the region's cash-starved local boys' clubs. The hope was that there would be so much publicity stateside that Ali couldn't help but notice the coverage. The thought was entertained that he might even be at Chicago's O'Hare International Airport waiting to greet him.

Contacting the US press and receiving their help might well have been thought of as a lucky omen for Johnny, as it had certainly worked eleven years previously, resulting in the front-page story and picture in the *Daily Sketch*. If they could receive similar coverage in Chicago, they knew they would be onto a winner. The 1966 front-page article was also tucked alongside his bundle of letters of support in Johnny's case as he prepared for departure.

A return plane ticket to Chicago had been purchased and Johnny informed his family that his dream was now about to materialise. I would imagine his wife and children were feeling quite optimistic, yet also couldn't believe what was happening. Johnny's bags were packed and he was confident that his dream had a great chance of becoming reality.

On 30 March 1977, a press conference was held at Newcastle Airport. At the time, Frankie Vaughn was appearing in Glasgow, but he flew down to Newcastle especially for the press briefing. He joined the committee members and announced that Johnny Walker would leave the next day, 31 March 1977, to personally invite the Greatest to come to Newcastle upon Tyne.

Johnny said,

'It has always been my dream to bring Muhammad Ali to the North East, a bit of the country that he has never visited. But when I tell him that Sonny Liston once came here, maybe he'll think he had better come and see us. We have a committee of businessmen who are being advised all along the line by solicitors and accountants, so the whole adventure will be run on the proper lines. It's just up to me now, to go to America tomorrow and see the great man himself. If he says "yes", I will be on the telephone straight away. And I know Shields would give Ali the biggest welcome that anyone has ever received in the town.'

As Johnny left the UK, any doubts would have surfaced at this time as they were only hoping that Ali would be in Chicago when he arrived. To add a little irony to Johnny's adventure, April Fool's Day was only one day away in the UK.

During Johnny's flight across the Atlantic, many thoughts would have crossed his mind. One might have been that he hoped the US press, who were supposed to be waiting for him at the airport, would take him seriously and wouldn't think his arrival was some kind of April Fool's Day prank or publicity stunt. However, his prevailing thought was that if he somehow managed to get access to the champion, he had a great chance to convince him. The main problem would be to locate Ali and get the opportunity to talk to him personally.

The good news before his arrival was that Ali had been true to form, paying lip service and giving much of his time out of competitive ring to help charitable causes. One charity night that Ali took part in would certainly have raised Johnny's hopes, as it was exactly the same type of money-raising event he was hoping to arrange in Newcastle. It happened only days after Ali's appearance at Jimmy Carter's US Presidential Inauguration Gala Ball (19 January) and inauguration ceremony (20 January) in Washington DC.

It was on 29 January 1977 that Ali turned up in Massachusetts, paying all the expenses of his entourage to travel to Boston, to take part in a charity boxing exhibition in aid of the Elma Lewis School of Fine Arts. That night, Ali boxed against six different opponents, one being a millionaire tycoon and former Golden Gloves champion Peter Fuller, who paid a hefty donation to the charity for the privilege of sparring with the champion boxer. Over 5,000 fans turned up at the Haynes auditorium to

watch Ali box a total of twelve rounds with Frank Smith, Walter Hains, Jerry Houston, Ron Drinkwater, Matt Ross and fifty-three-year-old Fuller.

It's not known if Johnny was aware of this particular event, but he would have touched down at Chicago's O'Hare International Airport on 31 March full of hope and optimism, despite arriving on the fourth anniversary of one of Ali's worst nights in boxing up to that point – having had his jaw broken and losing to ex-marine Ken Norton on 31 March 1973.

However, it was still looking promising for Johnny to get an opportunity to see Ali, as the champion had just recently returned to Chicago from Hollywood, Los Angeles, where a few days previously, on Monday 28 March 1977, he made a surprise appearance at the forty-ninth Annual Academy Awards ceremony.

On that night in Hollywood, Sylvester Stallone, whose boxing film *Rocky* had just been awarded top honours for Best Picture, was on stage to co-present another award – Best Supporting Actress – when Ali walked onstage unannounced. Ali's surprise appearance brought a round of applause from the star-studded audience and left Sylvester almost speechless. Ali told Stallone that it was he (Ali) who was the real Apollo Creed, in reference to the fictional champion that Rocky battles against to an exciting fifteen-round standstill.

After the ceremony, Ali travelled back to Chicago and, two days later, on Wednesday 30 March (the day before Johnny's arrival), attended a press gathering at Water Tower Place. What he said, although unknown to Johnny Walker, would have fuelled all his optimistic hopes. Ali was speaking to city leaders on the way to reach heaven after their time on earth had ended. This was to partake in good deeds and to be generous with both time and money to those less fortunate than themselves. Muhammad also mentioned the possibilities of taking part in another money-raising charity boxing exhibition with the man he met only a few days previously at the Academy Awards ceremony, Sylvester Stallone.

Johnny touched down at Chicago O'Hare airport one day after the press briefing, on Thursday 31 March (1 April UK time), more than likely wondering what type of reception he was going to receive. He knew Dick Kirkup had alerted the Chicago press about a crazy Englishman's mission to trace the world heavyweight champion, so with Dick's assistance he was hoping to be greeted by hoards of waiting US press.

When he walked through into the busy main airport arrival terminal, he scanned the area for journalists, but unfortunately and perhaps surprisingly, there were none to be seen. Initially he thought that they might arrive later, but no one turned up, so the only thing he felt on arrival was a certain

amount of dejection, as there were no press, no representatives from the champion's management and certainly no Muhammad Ali there to greet him. Stranded, with only a bunch of US dollars in his pocket, he quickly had to face the stark realities of the situation.

No one knows whether Johnny picked up a newspaper on his arrival, but if he had picked up a *Chicago Daily News* late that day, at least he would have read the promising story of the boxer being in the city and his talk on how keen he was to help those who needed it most. However, the afternoon edition of the tabloid was reporting a story that had broken the previous day, just after Ali had completed his talk to the press and city leaders on Wednesday 30 March. It was now Thursday 31 March and events in Muhammad Ali's life had a habit of changing fast.

The reason why there was no press welcome for Johnny was because somehow Dick Kirkup's telephone call to the *Chicago Daily News* had been misplaced. Dick was reassured that someone would interview Johnny on arrival, but the message somehow wasn't acted upon. So, Johnny arrived in Chicago without any welcome, or even the potential of a newspaper write-up.

Geordie Johnny spent a night in a hotel near the airport and decided he would have to take matters into his own hands. The next morning, he made a beeline to the offices of the *Chicago Daily News* himself and spieled out his story, hoping they would somehow come to his aid. He told them that he had made the long overseas journey in the hope of reaching Muhammad Ali and he wanted to ask him a massive favour of coming over to Newcastle upon Tyne in Northern England to help all the young 'uns there.

Staff from the *Chicago Daily News* said they would try to help, but sadly disappointment followed when he was informed he couldn't meet Ali, as the boxer was no longer in Chicago – or, for that matter, in the State of Illinois – as he had left soon after the press briefing at Water Tower Place on 30 March.

It seemed the only thing Johnny was going to get from the windy city was an early boarding pass onto a return flight to the UK, but before he left, the editorial staff of the newspaper were interested enough to write a column for their evening edition about his 'hard luck' story and wasted transatlantic journey. The story ended up on a front-page spread and, that evening, on Friday 1 April (yes April Fool's Day, US time) Johnny's face and story was plastered over every copy of the *Chicago Daily News*.

Every Chicago citizen who bought a *Daily News* that Friday afternoon couldn't miss the story of how Geordie Johnny travelled thousands of miles

from somewhere called Tyneside to invite Muhammad Ali to his home city at the same time of the Queen of England's planned arrival in July. The tabloid labelled his mission a failed one as he had arrived armed only with hope, and had no prior contact with the champion and no invitation, so it looked like he would be returning home with nothing.

Johnny, disappointed, disillusioned and dejected, was planning on packing his bags for his return trip to England, possibly thinking of the best way to break the news back home that he was returning empty-handed. At least he could show everyone who had been involved the front-page newspaper story, which proved that he went all the way to try and reach the champion boxer.

However, unknown to Johnny, there was some background manoeuvring taking place between the *Daily News* staff and Ali's manager, Herbert Muhammad, who had an office in Chicago. They had relayed Johnny's wasted journey story to him, and Herbert, maybe initially thinking it was some kind of April Fool's Day joke or prank himself, soon found out that the story was indeed genuine. A British guy, who wasn't known to him, Ali or his staff, had travelled halfway across the world, hoping to meet the champion.

Muhammad himself was now out of state at his ranch in Berrien Springs, a small town near Benton Harbour, Michigan. He first received the news via a phone call from Herbert's office. Ali then, amazingly, instructed them to find the man who called himself Johnny Walker and bring the Brit out to his ranch. Muhammad was keen to hear what Johnny had to say and Herbert Muhammad seemed to be helping too, writing a letter of initial agreement to Johnny's request. It was promising that Herbert put his personal support in writing, but it was only the world heavyweight champion himself who held the key to Johnny's ultimate dream.

The news that the champion wanted to personally meet with Walker was then relayed to the *Daily News* staff, whose reporters were then sent on their own 'Mission Impossible' to try to locate a 'Geordie in Chicago'. Searches were made and hours passed as staff went in search of Johnny. But Walker seemed to have disappeared and they were initially unable to track him down. Finally, though, it was smiles all round when Johnny eventually contacted the newspaper himself.

He was rewarded with the heart-lifting news that he might not have to book his seat on that return flight to the UK after all, as Ali was now aware of the April Fool's Day front-page story. An ecstatic Johnny was then told to prepare himself because he was going to be taken on an out-of-state journey to personally meet the champion at his ranch home. No one could help him after that, not even Ali's manager or the city newspaper, as it was up to Geordie John to convince the king of boxing of his Tyneside idea.

Shortly afterwards, Johnny found a flash red Cadillac Eldorado parked outside his hotel, all ready to escort him to the doors of the champion's ranch. Clutching the written agreement from Ali's manager, Johnny jumped in, confident his dream was now about to come true. The *Daily News* staff, keen to follow Johnny's story to its conclusion, also sent along a reporter and photographer to record how 'Mission Impossible' would end.

Ali had purchased this 88-acre farm in Berrien Springs for $400,000 in 1976. It was even rumoured that notorious Chicago gangster Al Capone (who, incidentally, shared the same birthday as the champion, 17 January) used to own the same plot of land in bygone years. Muhammad also used the farm as a makeshift training base, and a boxing ring and punching bags were installed in one of his outer barns.

As Johnny sat in the back of the Cadillac, I would imagine him thinking of how his long-held dream was now beginning to materialise. Also, if only the people 'back yem' could see him now. After a two-hour drive, the car entered the small town of Berrien Springs, and then made its way along a lane that led up onto the vast grounds of the champion's countryside kingdom, which was situated near the St Joseph River. Johnny was escorted into Ali's home and waited nervously for the his return, as the boxer just happened to be out surveying the grounds in one of his many vehicles.

When Muhammad returned, it was noted by the accompanying two members of the *Daily News* staff that Johnny was suddenly hit by a 'wall of nervousness' and lost his normal gift of the gab, as the sudden realisation of all his dreams, planning and publicity had come down to this one moment. He was in Ali's home, but the task of somehow convincing the great man towering before him to pop over to the 'Toon' for 'nowt' suddenly seemed more difficult than he had first imagined. Johnny's demeanour wasn't lost on Ali though, and the champion sat him down, calmed his nerves and asked him why he had travelled all those miles just in the hope of meeting him.

Still shaking, Johnny told Ali that he came on the long journey to ask him a favour. He told him about how the kids back home needed his help and how, if he accepted his invitation, lots of money could be raised to help them.

Muhammad sat in a chair and Johnny's nerves slowly began to evaporate, just like the old fog lifting off the River Tyne, as he told Ali about his fantasy of bringing the heavyweight champion to the streets of his home town of South Shields and how the citizens of Tyneside were a unique type of people, known as Geordies, who were a homely, friendly bunch and who would give him one of the greatest welcomes he had received anywhere in the world.

Johnny relayed his vision of how, if he accepted, the Queen of England and the king of boxing would be in the city at the same time, and told him about the time Sonny Liston once rode on a white horse through the streets of Newcastle.

Johnny, confidence growing, told Ali that most of the boys back home weren't well off financially and didn't have proper facilities at their boys' clubs. Johnny appealed to Ali, saying that if he came over, he could help change their plight. Muhammad sat and listened as Johnny showed him all the letters of support from around the UK, both urging and hoping that Ali would accept his invitation. Johnny also pulled out the *Daily Sketch* front page that told the story of him and his son meeting Ali back in 1966.

As the champion looked over the letters and newspaper article, Johnny might well have mentioned to him that most folks back home thought his dream of him ever agreeing to come to Newcastle was 'impossible' and even though everyone wanted him to succeed, most felt he wouldn't.

At first, Ali didn't say much, as he must have been approached by all sorts of characters over the years wanting him to consider every proposal imaginable, including bogus business deals and endless money-raising schemes. However, Muhammad wasn't known for judging people by flash suits, business cards and large bank accounts. He was more liable to give his time to those who were sincere and genuine, especially those that looked to help others.

Ali listened and soon realized that Johnny's plea for help wasn't based on self-interest, but in a genuine desire to help the kids back home, so it wasn't surprising that Muhammad soon embraced the foreigner with the strange-sounding voice who had arrived in the hope of helping others.

A smile stretched across Muhammad's face as wide as the Tyne Bridge and he said that God must have sent him to help those kids in his home city. He would happily accept his invite, and told Johnny that he could definitely count on him going across the world to Newcastle to help the children there. Ali also repeated what he'd said to civic leaders in Chicago only a few days previously and said that Johnny's attempts to help those kids would be the key for him to one day reach heaven and that was his aim also, so he would definitely accept the invitation.

Johnny couldn't believe it: he heard Ali say the words that he had always dreamed of and stood in disbelief as the accompanying *Chicago Daily News* staff photographer, John Tweedie, shot pictures of Ali and him together holding the preliminary acceptance letter from Herbert Muhammad. The letter contained an agreement to come to Tyneside on the basis of Ali's approval and that all travelling expenses to the UK

were covered. Ali, now convinced that he should go to this place called Newcastle no matter what, seemed unconcerned about any of the written demands of his manager, as he was definitely set on going to help the kids out and meet the Geordies.

And the surprises didn't end there. Ali's wife-to-be, Veronica, was also at the ranch that day, and Muhammad turned to her and suggested that Johnny's offer to go to Newcastle in July could also be used as part of their honeymoon after their marriage, which was planned for June. Veronica smiled and agreed as Johnny sat, staring in disbelief. The thought of the champion and his new bride spending part of their honeymoon on Tyneside must have been hard for even the ever-optimistic Johnny Walker to visualise, but Ali said it and Johnny knew he was serious. But would people back home believe it? Trying to convince people that the Greatest was not only going to arrive on industrial Tyneside, but would also spend part of his honeymoon there would take some doing.

Chicago was believing it, though, as the next day the story and pictures of the conclusion to Johnny's American 'Mission Impossible' adventure were splashed over every front page of the weekend edition of the *Daily News* (2/3 April). The mission ended up a successful one after all, said the tabloid, as Johnny had tracked Ali down (with the help of the *Daily News* of course) and was now leaving with his agreement to travel to his city in July and help raise money for youth clubs.

The formula Johnny used with the *Daily Sketch* back in 1966 and the front-page results it led to had been repeated on a mind-boggling scale, but it still didn't end there for Johnny, as he was also invited to spend some privileged time hanging out with the Greatest. Johnny was shown around Ali's farm and was even led inside one of the barns that had been converted into a makeshift boxing gym. A heavy boxing bag, speed bag, boxing ring and skipping rope were the only equipment inside, as these were the only things – apart from heavy army boots that Ali slipped on for early morning roadwork – that the champion used to keep his body toned.

Muhammad then invited forty-three-year-old ex-amateur middleweight boxer Johnny Walker to spar a couple of rounds with him in his personal boxing ring. All speculation as to the world champion's next opponent was put aside for the moment as Muhammad Ali faced Johnny Walker in a converted barn in the Michigan countryside. In one corner stood a painter, decorator and former amateur middleweight Golden Gloves champion, and in the other stood the current world heavyweight champion. The two proud fighting men slung fun sparring punches at each other, with Geordie

John picking up a slick nick on the corner of his eye when the punching exchanges heated up.

Johnny later said,

'Ali invited me to spar with him in the ring and my footwork is not what it used to be and I failed to dodge a quick jab. It caught me slightly, but even in fun the punch was enough to nick the corner of my eye. It's nothing serious, of course, but I hope it leaves a little scar so I can always show people what the Greatest did to me in one day of fun.'

Johnny may have managed to stay on his feet during the sparring session, but he was knocked off them by Muhammad's kind hospitality. Johnny also appeared on television with the champion. On an impromptu news programme, Ali declared that it wasn't just England that sent Johnny on a mission to help kids, but God himself. He said that he must now go to help the deprived youngsters in Johnny's city in England.

While Johnny was in America, Jimmy Stanley and Larry Shinwell could hardly sleep, wondering how Johnny was getting along. When the phone eventually rang in the Stanley home, Jimmy answered and heard Johnny's booming voice on the other end, telling him with great excitement to prepare the greatest welcome ever for the world heavyweight champion, because Muhammad Ali was coming.

Jimmy couldn't believe what he was hearing on the other end of the crackly transatlantic phone line and kept asking Johnny to repeat what he was saying. Johnny told him the story of how he'd not only met Muhammad Ali, but was invited to the champion's home and had been given his personal promise that he would come to Tyneside in July.

When the phone connection ended and Johnny's words started to sink in, an excited Jimmy could hardly contain himself and immediately phoned Dick Kirkup with the exciting news. Dick answered the phone to the sound of Jimmy Stanley excitedly relaying the verse of the boxer's famous 'Sting Like a Bee' poem, and repeating over and over that Johnny had got his man. Ali was coming.

Back in the States, it had been a unique experience for Johnny to spend time with the Greatest. However, an excited Johnny was too busy thinking about the preparations required to finalise such a visit. Also, Johnny pictured the disbelieving looks on people's faces back home. What would the disbelievers say, when they saw Muhammad Ali walking down the streets of Newcastle?

Before leaving America, Johnny was handed Muhammad's personal and office telephone numbers, so he could keep in contact while all the arrangements were being finalised, along with a signed copy of his 1975 book on his life, *The Greatest*.

Johnny's time with Ali in America soon ended and it wasn't long before he was sitting on his homeward-bound flight, carrying some unique memories and many thoughts of exciting plans.

NEWS OF THE GREATEST REACHES HOME

Johnny eventually arrived at Newcastle Central railway station (from London) on 4 April 1977. He had only been away a few days, but Jimmy, Larry, Dick, local television reporters and hoards of press were there waiting to greet him. Johnny announced,

'I have achieved the impossible dream. I am bringing World Heavyweight Boxing Champion Muhammad Ali to Tyneside in July. A group of businessmen sponsored my trip to Chicago to extend personally the invitation to Ali, and you can take it from me, that during Ali's visit he will come to South Shields.'

It was initially announced that Ali would arrive on Tyneside on Friday 15 July (the day of the Queen's visit) and leave on Sunday 18 July. It was hoped he would be the guest of honour of possibly two functions, which would include other past and present British boxing champions. If the plans were realised, the city would host two unique 'Parade of Champions' fundraising events, headed by the Greatest, Muhammad Ali himself. All monies raised would go to improve the facilities of the region's boys' clubs.

An overjoyed Jimmy Stanley, who was still finding everything hard to believe, said,

'I just don't know how Johnny has pulled this off. Ali has the best known face on the planet and no one in history commands appearance fees to match those he demands and gets – yet we have him for nothing.'

Larry Shinwell chipped in and predicted the occasion would be one of the greatest the North East had ever known, with the Queen's visit and Jubilee celebrations taking place at the same time.

Johnny showed the press the tentative agreement letter he had received from Herbert Muhammad and confidently reassured everyone that Ali would definitely be on his way in July. He also said that he was well received in Chicago and told everyone about his story hitting the front pages of the American newspaper on two consecutive days. An exhuberant Johnny told the press they were looking forward to organising everything for Ali's trip, but that he was still finding everything hard to get his head around.

Two days after Johnny's UK return on 6 April 1977, all speculation about who Muhammad Ali's next real ring opponent would be was finally put to rest. It was announced that the world champion would defend his title for the eighteenth time on a Don King promotion against Alfredo Evangelista. The bout would take place at the Landover Capitol Centre in Maryland, on Monday 16 May 1977, and would be promoted ironically as 'The Parade of Champions', as fellow champions Roberto Duran and Alfredo Escalera would also defend their respective world titles on the same promotion. Ali would have been inactive seven and a half months before going into a competitive fight and the timing of the bout meant he would face Evangelista only three days before the premiere of his new film *The Greatest*, which was set for Hollywood on 19 May 1977.

Evangelista's record showed that he had been a pro fighter for just over a year and had only sixteen pro fights, of which he had not only lost his last bout, but had never been further than eight rounds previously. Evangelista seemed to be the pick for Ali facing an opponent of his own choosing before tackling the No. 1 contender. However, to face the champion, a fighter still had to be rated, and many were puzzled at Evangelista's entrance into the top ten rankings.

On both sides of the Atlantic, there would be a bit of convincing to do. In the US, the problem was to try to convince the world's press and fans that Evangelista was a credible opponent for the champion. Back on Tyneside, the committee would have their work cut out trying to convince everyone that Ali would make good on his promise to the Geordies.

Promoter Don King, who first came into boxing after convincing Ali to take part in a charity boxing exhibition to raise money for a hospital in his home city of Cleveland, tried in vain to convince both the American public and press of the viability of Ali's challenger, but people quickly dismissed Evangelista's chances and many saw the fight as little

more than a well-paid exhibition bout for the champion. Despite Ali's advancing years and hanging onto his title only by the skin of his teeth in his bout the previous year, it was believed that outside of the top three heavyweights, every other contender would be a mismatch.

In the build-up to the bout, it didn't help that Ali seemed more interested in talking about anything other than boxing and defending his title. In one press conference, he declared that he had so much world power that the President of the United States, Jimmy Carter, should make him a World Peace Champion. He may have been right, as he was one of the few people in the world whose popularity stretched through all cultures, religions, colours and nationalities. Ali's 16 May title defence was little over a month away, but his mind didn't seem to be on the upcoming championship prize fight.

Back on the other side of the Atlantic, 'DK's' publicity machine – not that of Don King, but that of our own Dick Kirkup – was handed the equally difficult task of convincing a highly sceptical Geordie public that the king of boxing would make good on his promise. For Dick, though, before ploughing ahead with headline stories about the Greatest definitely coming to Tyneside, he needed to convince himself first. A confident Johnny had told him that Ali would not only be coming to Newcastle, but also to South Shields. Dick needed to know for certain if the champion was serious. So, he wanted to speak to Ali personally and hear the words from his own lips.

If it was true, and the champion did come, it would be one of the greatest occasions ever for the seaside town. Johnny had previously given Dick Ali's personal telephone number, so one early morning (3.45 a.m.) in April Dick rang Muhammad's farm in Michigan. The champion answered the phone, and after introducing himself, Dick asked straight out whether he was truly serious about coming to South Shields.

At first, Ali was inquisitive about where South Shields was in relation to Newcastle. When he told him the seaside town was only a few miles down the road from the city, Ali reassured Dick that he would visit everyone in the town, saying he would even 'go by cab' to meet everyone there. All remaining doubts in Dick's mind about Ali's sincerity were extinguished when Ali quietly explained to him that he wasn't joking about coming, as his word was his bond and if he said he would be in South Shields in July then he would make sure that he would be there. He wouldn't let anyone down.

When the call ended, Dick knew he could now begin his publicity plans with both optimism and confidence. The sports writer believed that Ali spoke with sincerity and was convinced that he was 100 per cent

serious about coming. Now that he was certain of Ali's intentions, Dick was quick to inform his many doubting readers in the *Shields Gazette* about the champion's transatlantic promise. The next day's headline read 'Muhammad Ali is Coming to South Shields'.

Shortly after Johnny's return home, the members of the organisation committee headed by solicitor Clive McKeag, Johnny, Jimmy and Dick were formally and publicly announced. The auditors appointed would be Richardson, Hall, Kennedy & Co. and the secretary would be Judith Gee. This trusted band of people included a solicitor, accountants, a boys' club chairman, a bank manager and a QC, as all matters relating to Ali's trip had to be run on a professional and especially a non-controversial basis. All money raised for the charity would also be under the tight scrutiny of Mr Clark, the manager of Lloyds bank on Westgate Road.

By late April 1977, what those on the committee had in mind for Ali's visit became clearer. It was planned for the centrepiece to be a gala dinner fundraiser held at the Mayfair ballroom in the city centre, where other past and present boxing champions would join Ali on an extravagant evening that would hopefully raise thousands of pounds. It was hoped that another well-known former world heavyweight champion might accept an invitation too. In 1977, he was still the youngest ever title holder and first man in history to regain a heavyweight title. This was Floyd Patterson. Committee chairman Clive McKeag said it was hoped that the world light heavyweight champion John Conteh would also attend.

An optimistic target of £75,000 had been set, with all funds going to the Tyne & Wear boys' clubs (funds raised would eventually be split between the Tyne & Wear boys' clubs and Durham boys' clubs), but they knew it would cost at least £10,000 to cover the costs of bringing Ali and his party over from the States.

Invites were sent out and acceptances were received from past and present boxing champions eager to take part in the Parade of Champions gala fundraiser banquet. Names such as Terry Spinks, Terry Downes and Chris Finnegan were reported to have quickly accepted their invitations.

Besides a fundraising banquet, it was hoped that the whole of Tyneside would get the unique opportunity of seeing the champion display his boxing skills, by asking Ali to take part in a similar exhibition bout to the one Sonny Liston took part in back in 1963. It was first mooted that St James' Park football stadium would be the ideal venue, as Ali's popularity was so high at the time that the committee believed tens of thousands of people would turn up. If Ali agreed, a huge amount of money would be raised on a special Muhammad Ali boxing day in the city.

What might have been even better was if they could persuade Ali and fellow Parade of Champions invitee WBC light heavyweight champion John Conteh to box each other in a friendly exhibition. Conteh had just successfully defended his title against Len Huchins the previous month in March 1977 and his popularity at that time wasn't a million miles behind Ali's. An event including both boxing superstars had the potential of selling every seat in the St James' Park stadium, and a sparring exhibition between the two in Newcastle wasn't beyond the realms of possibility, as Conteh had already sparred with Ali previously – the first time being in 1972, when both boxers appeared on the same outdoor bill at Croke Park in Dublin. If anyone could pull that one off, it had to be Johnny himself, with his already cemented link with world light heavyweight champion Conteh.

A sponsor quickly came forward to finance Ali's travel costs from America, and the Holiday Inn hotel, based not far from Newcastle Airport at Seaton Burn, would do their bit for the fundraiser, saying that the champion and his entourage could stay there free of charge. These generous offers would result in more money being channelled into the boys' clubs charity.

During April, Johnny also made a visit to Peter Gillanders, who was the press officer for South Tyneside council. When Johnny told Peter that the plan was for Ali to visit South Shields, Peter was much like everyone else. Despite the newspaper stories, he was finding everything hard to believe. However, once they knew for certain that Ali was definitely coming, plans to coincide Ali's trip with the Queen's Royal Jubilee visit, set for a sports stadium called Gypsies Green, were put forward to councillors and quickly passed. The Queen would visit the open-air sports facility on 15 July and Ali on Saturday 16 July. A civic reception for the champion at the Town Hall would follow the morning's events at the seafront stadium.

However, even if the same stadium and seating could be used for both events, there would still be an enormous amount of preparation to complete before July. Both days would include different shows, with each having different facilities and requirements. Peter explained the complexities of running two major events so close together, saying,

'Invitations would have to be sent out, programmes would have to be printed and events would have to be arranged. Also, arrangements would have to be in place for the smooth running of Ali and the Queen's visit on consecutive days.'

(Interview with Peter Gillanders, 2005)

So Saturday 16 July in South Shields was set to be a Muhammad Ali carnival day, with various other attractions supporting his time at with at Gypsies Green. All money raised on the day would be shared between the boys' clubs charity and a special Jubilee fund. It was expected that massive savings would be made by being able to use the same facilities at the stadium for the seperate events. If everything went to plan, it would be the biggest couple of days ever for the seaside town of South Shields.

With the Queen and Ali appearing at the same stadium and visiting the town so close together, it didn't take long before many in the press voiced concerns about the champion's carnival day being more popular and overshadowing the monarch's Silver Jubilee event. It was suggested that it might have been a good idea for them to visit the stadium on the same day, but this was not logistically possible, with each visit having different events scheduled. Also it was not the organisers' intention to take away any attention from the royal visit, so splitting the two events into separate days was the only option.

As regards Ali actually meeting up with the Queen while in the region, it was highly unlikely as they would be in South Shields on different days and have different itineraries. Besides which, he had already met the Queen as recently as July 1976 in the United States, when she was in Washington DC as part of America's bicentennial celebrations.

ALI KEEPS BUSY

By May 1977, plans were well underway for Ali's arrival in July. Back in the States, Ali had completed some training at his farm in Berrien Springs, Michigan, initially scaling a hefty 238 lbs (17 stone), but then moved to train in the sweltering heat of Miami Beach, Florida, in April, giving himself only four weeks to lose at least a further 10 lbs in weight. While in Miami, Muhammad boxed exhibition rounds against nineteen-year-old future WBA heavyweight champion Mike Dokes and fellow boxer Jody Ballard. Round after round saw Ali treating fans to a convincing impersonation of his younger self. During his sparring with Dokes, Ali kept shouting to the crowd that he was still 'the Greatest of all time'. At one point, he moved into a corner and invited Dokes to take potshots at his swaying, ducking head. Dokes attempted this by throwing fifteen solid lefts and rights, but none connected, as Ali ducked, dodged and slipped out of harm's way.

Interestingly, the champion's exhibitions took place at the Miami Convention Centre – this being the same venue where, just twelve years previously, twenty-two-year-old Cassius Clay shocked the world by defeating former Newcastle visitor and world champion Sonny Liston after six blistering rounds. The fight ended with Sonny failing to come out to face young Clay for the seventh round, claiming a damaged shoulder.

Ali lost the weight in training, but many in the press still criticised his preparations, even though his training was better than it had been for his last ring appearance at the Landover Capital Centre, against Jimmy Young in 1976, where many felt a far from top condition Ali, scaling at his career heaviest up to that point of a whopping 230 lbs, was gifted the decision to cling onto his title. This time, Ali turned up at the Capitol Centre a leaner 221¼ lbs for his well-paid return to Landover, while Evangelista weighed in at 209¼ pounds.

Tickets for the bout were priced at $150 for 'golden' ringside seats, then scaling down from $100 to $20, where someone would only catch a bird's-eye view up in the bleachers. Before the bout, Muhammad generously donated $200,000 to buy 3,000 tickets to give away to the poor of nearby Washington, so they could get to see him fight.

On the night of the championship bout, a crowd of 12,000 turned up in the 19,000-capacity arena to watch Ali go through his routine. Fans would see his famous shuffle, rope-a-dope, and his act of feigning being hurt, but the fight was little more than an exhibition for the champion, as Evangelista didn't land many meaningful punches during the entire fight. Ali was sometimes content to lie on the ropes, letting his opponent blaze away with punches that had very little effect.

The fight went the full fifteen rounds, with the pace set by the champion, and afterwards Evangelista seemed pleased he had lasted the full championship route. However, most of the rounds Ali lost were the ones he gave away, and even taking into account these subtracted rounds, two out of the three judges awarded Muhammad twelve rounds, with the other judge scoring eleven for the champion with one even.

The most noticeable factor about the night, though, was that Ali seemed to just be going through the motions, sometimes even appearing bored. By the seventh round, boos could be heard from sections of the crowd, and spectator and contender Jimmy Young left before the final bell, seemingly unimpressed with the boxer's lacklustre performance.

Of course, Ali saw it differently to the critics, saying that his performance was 'proof' of his legend status, and that his thirty-five-year-old frame could still 'dance' for fifteen rounds against a much younger man. As he spoke, a song from his movie, *The Greatest*, called 'Ali – Boomaye' was relayed through the loudspeakers in the arena. During the post-fight interviews, Muhammad made reference to Ken Norton's impressive and devastating KO win against 'White Hope' Duane Bobick, the previous week at Madison Square Garden. In some quarters, it was believed that Ali didn't relish a fourth meeting with the man who had broken his jaw four years previously, and had taken him to two further whisper-close decisions later in 1973 and 1976. However, a fourth meeting with Norton looked a possibility as George Foreman's change of heart about boxing would again propel the winner of a now proposed fall bout between 'White Hope Destroyer' Ken Norton and the man who whipped Foreman, Jimmy Young, into a future championship bout with Ali, which would probably be promoted as the champion's boxing farewell.

Muhammad's relatively easy night's work against Spanish citizen Evangelista, and the purse he picked up for the forty-five-minute engagement,

would certainly go some way to ease the financial strain of a recent and costly divorce. Also, the ease of the bout would ensure him not turning up to his wedding in a few weeks' time sporting any battle damage.

However, some sections of the press seized the opportunity to criticise the fifteen-round championship fight, saying it was little more than an exhibition, while others called the fight some kind of pre-publicity stunt for the release of the upcoming movie. One stinging comment came from the previous year's US Olympic boxing coach, the respected Rolly Schwartz, who commented on the quality of Ali's opponent, saying that all the top American amateur heavies could easily flatten the man who just challenged for the premier professional title.

In Muhammad's defence, he was due an easier night's work, as his last fight was against his nemesis, Ken 'Jawbreaker' Norton, and that bout ended up in a tough and highly controversial fifteen-round encounter for the champion. However, the most notable after-fight comment came from his long-time doctor, Ferdie Pacheco, when he said that Ali should retire now because he felt that he was just going through the motions in fights and was not properly motivated, as in the one against Evangelista, treating them only as paydays.

The champion knew that he couldn't box on too much longer and said that two more fights were the maximum before 'definitely' retiring. His purse for the one-hour appearance on ABC television was $2.5 million, while Evangelista earned a then career high of $85,000

Three days after the bout on 19 May, Ali the boxer put his gloves aside to take up his role as Ali the movie star, as he arrived in Century City, Los Angeles, for the grand premiere of *The Greatest*. This would be followed be a whistle-stop promotional tour.

Muhammad said he had found it easy to make the transition from Greatest boxer to becoming the greatest actor, as he said he had been acting throughout his entire boxing career. The 'acts' really took off after young Cassius Clay met up with the flamboyant wrestler 'Gorgeous' George when he was in Las Vegas to fight Duke Sabedong in 1961. The outrageous and hilarious antics of the wrestler caught on with Cassius and he started adopting his own brand of pre-fight ballyhoo in front of the camera. The wrestler proclaimed he was 'gorgeous' and the boxer boasted he was 'pretty', but the acts of vanity combined with talent and determination still led them both to become the biggest draws in their respective fields of sport and entertainment.

During his career Ali was offered various movie roles, but turned most down as he only wanted to accept parts that were relevant to his inner

beliefs, or reflected his real-life image. He was quick to criticise and dismiss X-rated roles, such as the ones fellow boxer Ken Norton had starred in, *Mandingo* and *Drum*.

However, this wasn't the first time Ali/Clay's name was displayed on the silver screen, as this came about in 1962, when Cassius Clay played himself as a boxer, and pummelled a fictional opponent called Luis 'Mountain' Rivera, played by actor Anthony Quinn, in the movie *Requiem of a Heavyweight*.

One other role that Ali accepted where he portrayed himself, but joined a cast of many other fictional characters, was released in the same year as *The Greatest*. However, it was his famous vocals that would be used in a voice-over of a cartoon caricature of himself in a children's cartoon adventure series called *I am the Greatest – The Adventures of Muhammad Ali*. The animated NBC television weekly show broadcast thirteen thirty-minute episodes. The kiddies' programme showed the famous boxer and his friends involved in various adventures each week until the show finished in 1978.

The movie *The Greatest* was produced by Brit John Marshall, and was effectively based on fourteen years of Ali's life, spanning from Cassius Clay's Olympic gold medal win in 1960 to him defeating George Foreman in 1974. Young Cassius was portrayed by Cassius Clay look-a-like Philip 'Chip' McAllister, but it was thirty-five-year-old Ali who would portray himself from the age of twenty-two.

Ali's brother Rahaman received a small cameo role, along with camp members and friends Jimmy Ellis, Bundini Brown, Howard Bingham, Gene Kilroy, Pat Patterson, Walter Youngblood and Lloyd Wells.

Of course, Ali had the starring role, with other famous actors, such as Ernest Borgnine portraying Angelo Dundee, Robert Duvall as Bill McDonald, a Miami promoter, and James Earl Jones in the role of Malcom X.

On the night of the Hollywood grand premiere, Muhammad arrived at the Plitt Theatre in Century City in a unique antique Mercedes, with thousands turning up to welcome him. It was a spectacular occasion, with stars from both the sporting and stage worlds joining Ali on the night.

A tiring multi-city promotional tour followed the premiere and the reception Ali received in New York was typical of the attention the champion got wherever he went. A walk through Times Square by the boxer-cum-movie-star brought the town to a standstill, with traffic stopped, and people cheering as he predicted his film would be bigger than *Jaws*.

If Ali had called it quits from boxing in 1976, wherever he travelled, the talk and questions from the media may have always centred around his new film, or his future as a possible serious movie actor, but as he decided

to prolong his fighting career through 1977, the subject invariably returned to what he was really famous for – boxing – and who was going to be his next opponent. Ali said that he might have one more warm-up fight, and then leave boxing with a $10-million super-fight against the winner of the bout between Jimmy Young and Ken Norton.

Don King, who had a contract with contender Larry Holmes, wanted him to be next in line. Although Holmes was undefeated, he had once worked as Ali's sparring partner at the champion's training camp at Deer Lake, Pennsylvania. Holmes helped him prepare for George Foreman, before eventually leaving his camp in search of his own boxing destiny. The champion certainly knew Holmes's ring style, which had many similarities to his own, so presumably Ali's people figured his former paid hand wouldn't give him too many problems.

Although Don King had promoted the champion's last title defence against Evangelista, King was receiving bad press at the time, involving ABC television and a boxing series called the *United States Boxing Tournament*. The American television giant backed King's idea of using ranked fighters taking part in elimination contests to find a separate US champion in each weight division. Only fighters ranked by the highly respected *Ring* magazine could take part.

Although on the surface this sounded great, it was soon discovered that certain previously unranked fighters, usually with connections or under contract to King, were miraculously finding themselves ranked in the television elimination tournament. Although the ABC television boxing series began in January 1977, it was cancelled with much embarrassment four months later in April when all the background shenanigans came to light.

The scandal couldn't have enhanced King's relationship with the world champion's management, and may have hindered his chances of getting Larry Holmes a title shot against Ali. Indeed, history showed that it would be a long three years before King promoted another Ali fight. However, when that happened, positions had reversed, as Larry Holmes was the champion and Ali was the challenger in a bout for Larry's WBC title in Las Vegas in 1980.

In 1977, the champion talked about another contender, Earnie Shavers, as a possible opponent before tackling the winner of Norton and Young in his final hurrah. Ali had let Earnie use his hillside training facility when he had his big break in 1973 against Muhammad's long-time spar mate, friend and ex-opponent, Jimmy Ellis. The training camp atmosphere of Deer Lake must have done Shavers good, as he despatched former WBA champion Ellis in the very first round in Madison Square Garden.

Eventually it was Ellis's conqueror, Earnie 'KO' Shavers, who found himself the favourite to be the champion's next challenger. A title fight against Ali would be a dream come true for Earnie who, ironically, had his first-ever amateur bout on the champion's twenty-fifth birthday (17 January 1967). While Shavers was taking part in this novice Golden Gloves competition, Ali was preparing to defend his world heavyweight title for the eighth time against Earnie Terrell (6 February 1967). Shavers' pro debut wouldn't take place until during the champion's enforced exile back in 1969. Since then he had amassed a ring record of five losses and one drawn contest in sixty bouts.

Madison Square Garden wanted to stage the bout, but there was a problem. Promoter Bob Arum already had a signed contract with Shavers and the Garden had an agreement with Ali for a bout later that year, but Madison Square Garden didn't want to co-promote with Arum, so both ended up battling it out in court. Shavers would be the the next in line for the title shot, but there would be much legal wrangling before he could swap punches with the champion inside a boxing ring.

7

DISBELIEF

In June 1977, Ali's future fight plans took a back seat, as he concentrated on his marriage to Veronica. Leading members of the sporting and show business world were sent invitations for the ceremony planned for Beverly Wilshire Hotel, in Los Angeles, 19 June 1977.

Geordie Johnny Walker received an invitation too, but he turned his invitation into something from which the whole region might benefit by coming up with the idea that Muhammad Ali's Beverly Hills marriage in June could be repeated in another ceremony on Tyneside.

Johnny came up with this idea one week before Ali's marriage to Veronica, when he called Chicago and spoke to a top aide within the champion's management. His name was Jeremiah Shabazz, who claimed to be the very man who first introduced Cassius Clay to the nation of Islam back in 1961. Jeremiah assisted the organisation of the Newcastle trip, and some details were discussed on the phone, but all talk soon turned to the wedding, which was set for Los Angeles the following week. Johnny said,

> 'Jeremiah asked me if I would like to be a guest at Ali's wedding and I almost said yes. But then, I thought instead of one man from South Shields going to the wedding in America, why not bring the wedding to South Shields at our local mosque? Jeremiah was surprised that we had a mosque. He told Ali about it and he said that Ali would love to go through a Muslim wedding ceremony in keeping with his faith. He said it would be a great honour to renew his vows on Tyneside.'

Dick Kirkup rang Mr Shabazz to confirm the story and the news coming back was that Muhammad would be thrilled that he could remarry Veronica in a mosque and just as delighted for it all to happen in Johnny's home town.

The news was not only a major scoop for both Johnny and the committee, but also for the then 2,000-plus Muslim community of South Shields. Their place of worship, the Al Azhar Mosque on Laygate Lane, had only opened its doors in 1972, and for Muhammad Ali to be married there was not only a major surprise, but would also be one of the most prestigious and best publicised events to ever occur at their place of worship. Mr Shah, chairman of the South Shields Islamic Trust, declared both his joy and honour at receiving the opportunity to host a second wedding ceremony for Muhammad Ali. He said the ceremony would be conducted by the local Imam.

The press were quick to use the confirmation for their news stories and the committee knew that this was a major development, as the event could only draw more interest from the people of the region. The ceremony was planned for Sunday 17 July 1977, less than one month after Muhammad's American wedding ceremony.

Ali had been married and divorced twice previously. His first marriage was to Sonji Roy in 1964 and his second was to the then seventeen-year-old Belinda Boyd in 1967. If Johnny had attended the Los Angeles wedding, he would have mingled with 240 other guests at the Beverly Wilshire hotel, including Muhammad and Veronica's parents, Ali's brother Rahaman and celebrities from the boxing and show business world such as former world champions Joe Louis, Sugar Ray Robinson and Jimmy Ellis. Johnny would also have met up with stars of the screen such as Warren Beatty, and Christopher Lee.

However, the front-page news on Tyneside, telling the story of how Muhammad Ali would be married in South Shields in July, was unfortunately having an adverse effect. No one believed it. Official press officer Dick Kirkup already had his work cut out convincing locals that the world heavyweight champion would turn up at all, never mind trying to get the same people to believe he would be getting married here too. People just couldn't, or wouldn't, believe that Ali would actually make good on a promise he'd made back in April. He was just too big a name at the time, more famous than any boxing champion that had come before him and some said better known throughout the world than all pop stars combined, as he was still known in some remote countries that had never heard of western celebrities.

Critics and most people in the North East were quick to dismiss the headlines. The idea of the Greatest getting married on Tyneside was beyond the bounds of reality for most people. 'Why?' was the question that most people asked, when he was already getting married in one of the most luxurious and expensive places in the world – Beverly Hills. Although I was a great fan of Muhammad Ali, my thoughts were no different from thousands of others. Surely, all the talk of Muhammad Ali getting married

in close proximity to pit heaps, shipyards and working men's CIU social clubs was no more than some kind of elaborate publicity stunt. Surely all the hype was only there to try to get people to buy tickets to various events where the champion might or might not show up for a few days in July.

Johnny and the committee members were well aware that most people were sceptical. If they could come up with a way of totally convincing people that Ali was definitely coming, then surely it would be easier to sell more tickets and convince everyone that he was going to be married here and spend part of his honeymoon here too. Ali's verbal agreement and the written letter of 'tentative acceptance' from his manager weren't enough. They needed more.

Again, Johnny came up with a solution. One day, he telephoned Ali directly from the office of Jimmy Stanley's scrap metal merchants in Swalwell, Gateshead, and spoke to him about how most people in the region just didn't believe he was serious about coming over in July. Johnny told the boxer that most were convinced he wouldn't show up at all and asked if he could somehow put his intentions in writing, so that they had something to use as firm evidence to convince all the doubters.

Ali may well have enjoyed the disbelief that was taking place on the other side of the world, as he always liked surprising people, especially ardent disbelievers. He stressed to Johnny that there was no way he wouldn't be coming and he would even arrive a few days earlier than previously agreed. This would give them more time to fit in events for the charity and for Ali to meet the people of the region. The champion sent off an international telegram to Johnny's Tyneside home. Now they would have something in writing to turn the doubters into believers and hopefully ticket purchasers.

When the telegram arrived, it stated that Ali would arrive on 13 July (he would eventually arrive on 14 July) and his travelling party would consist of his immediate family members, himself, Veronica and baby Hana. Also included would be his best friend and personal photographer, Howard Bingham. The rest of the Ali's travelling party would consist of personal assistants and members of Veronica's family, bringing the total of people travelling to Tyneside to fourteen (including baby Hana).

A delighted Johnny waved the telegram and announced to the press that he now had the vital document that would silence all the sceptics and doubters. Ali helped further, when he spoke by a transatlantic telephone link-up from the US, which was broadcast on local television stations. He told all the region's viewers that he wouldn't let Johnny down and was looking forward to meeting everyone in the North East of England. However, even after all this, many locals remained unconvinced.

People wanted to believe Johnny and truly wanted Ali to come to Tyneside – none more so than me, as I was a long-time, ardent fan of the champion boxer – but everything that was being said in the press about wedding ceremonies and honeymoons seemed more of a fairytale. The story could be best equated with a local working guy telling everyone that he was bringing Elvis Presley to town – nobody would believe him until they saw, with their very own eyes, Elvis coming over the Tyne Bridge singing 'Blue Suede Shoes'.

True, international entertainers did arrive and perform in the region, but most were part of UK-wide promotions, or their arrival was funded by professional promoters. Sonny Liston and Primo Carnera's arrival came by way of multi-city boxing exhibition and wrestling tours in which they were taking part, and Joe Louis's invitation came by way of a London booking agent and a Newcastle nightclub owner. All three champions were also paid a fee for their time in Newcastle. Indeed, the story of Ali's visit would have been more believable if he *was* getting a grand fee for coming.

Comparisons could have been made with Dr Martin Luther King's arrival in Newcastle back on 13 November 1967. However, the civil rights leader was only in the UK itself for twenty-four hours and made the train trip up from London to Newcastle to accept an honorary degree from the Chancellor of Newcastle University, the Duke of Northumberland. His unique stop-off in the city, however, was arranged by an institution, the university itself.

This was different. Despite Johnny's link with Conteh, and having a team of professionals supporting him, he was still a local working guy, saying that he was not only going to bring the Greatest to town without any hefty personal fee attached, but also that Ali was going to get married and spend part of his honeymoon here too. Hard to believe was an understatement.

To compound matters of uncertainty, one of the last times a reigning world boxing champion was invited to a major boxing show in the North East was still clear in many people's minds, especially those from the local boxing fraternity. This happened on 18 November 1975, when none other than WBC light heavyweight champion John Conteh was invited to the North East, to present trophies to amateur boxers at the Sunderland Locarno Ballroom on Newcastle Road, Sunderland. Ironically, the bill was co-sponsored by none other than one of the current Ali sponsors, Jimmy Stanley, and a local car dealer called Harry Block.

World champion Conteh had already turned up on Tyneside a few months earlier for some public engagements and to meet his friends and army of fans. He was invited back to the region to one of the most extravagant amateur boxing bills I could recall at the time. Every local amateur boxer was keen to participate and the show was widely

publicised. I was seventeen years old at the time and turned up, eager to take part in the boxing programme myself, but only really to receive the prized opportunity to shake the mitt of 'King' John afterwards.

The two local businessmen must have spent a small fortune on trophies and putting the show together. A glossy programme was produced, showing Conteh's photograph on the front cover. However, to the huge disappointment of the sponsors, organisers, boxers and the vast crowd that paid to attend, the star guest didn't show up, even though the promotion was centred on the popular world champion. That night, the arduous task was given to MC Ted Hooper to explain to everyone in the disappointed audience and boxers taking part that superstar John Conteh wouldn't be coming along after all.

So, it was understandable that many still kept their money firmly in their pocket and most remained sceptical of such an unlikely event ever coming to fruition. Even when official 'Parade of Champions – Ali comes to Tyneside' programmes were in the process of being printed, most remained confident that, when the time finally came, something would cause Ali to end up being a no-show. The news that Ali was now going to be married here as well really only made it harder to believe.

Dick Kirkup's task of convincing doubting Geordies was a huge one to say the least. He ran headline after headline in the *Shields Gazette,* such as 'Ali will be in Shields – and that's official' and he relayed up-to-date news to other regional newspapers that the champion would definitely be on his way soon, but even he said at the time that people were being more than cautious and were apprehensive when it came to putting their hand in their pockets to purchase tickets.

Doubters and sceptics increased en masse when the proposed Ali wedding that everyone read about quickly fell apart. Laws governing religious marriages by foreign visitors meant that the Alis would have to be in the country for at least seven days for a civil marriage to be possible. Everyone knew that, due to Muhammad's commitments, staying that amount of time wouldn't be possible, which meant they could not comply with these rules.

The news soon reached those at the Al Azhar Mosque in South Shields, where Mr Muhammad Kaid, secretary of the Laygate Lane Mosque, expressed his disappointment, saying that the Alis now couldn't be married in the mosque. However, just as quickly as the ceremony was called off, an alternative solution was found after the registrar said that there were no rules or reasons that could stop some kind of special blessing taking place in their place of worship.

The news was relayed to Chicago, but the boxer's staff were still happy that an alternative blessing could be arranged and agreed for all plans to proceed as before. Jeremiah Shabazz expressed his delight that Mr and Mrs Ali would still be able to have their wedding blessed by the local Muslim community.

Plans for the events on Tyneside heated up, with Dick Kirkup taking charge of the South Shields side of the trip, and South Tyneside Council having programmes printed for a seafront carnival on 16 July. Dick organised the Queen's Silver Jubilee open-topped bus to parade the champion and his party through the streets of Shields. The police worked in partnership with him and agreed a route that would begin at the south side of the Tyne Tunnel. Here, the champion's party would swap vehicles to board the bus and follow a set route along York Avenue all the way to South Shields marketplace, where a jazz band would join the Parade all the way down to the seafront.

It was hoped that the open-topped bus procession would also include top entertainers Morecambe & Wise, Harry Secombe and John Conteh. Over 15,000 people were expected to turn up at the Gypsies Green Stadium for 'Muhammad Ali Day'. At the stadium, the Mayor of South Tyneside, Cllr Sep Robinson, would officially welcome Ali. Alan Evans, the world darts exhibition champion, was also expected to perform an exhibition on the day, with Ali possibly challenging him with the feathered arrows. There would be a 20 pence entry fee and a £2,000 target was set for the two charities.

Announcements quickly followed. A reception would be laid on after the wedding blessing by Scottish & Newcastle Breweries at Brandling House at the city's racecourse, Gosforth Park. Organisers also stated that Newcastle councillors had passed plans for the champion and his wife to attend a civic reception at the Lord Mayor's Mansion House on Fernwood Road, Jesmond, on 15 July. Ali would also attend a talk-in at the council-owned and recently opened (1976) Eldon Square Recreation Centre, which had a seating capacity of 2,000 people. The talk-in would take place on 16 July, where he would answer questions from other sportsmen and local Geordies for about sixty minutes. Mr Wilf Gillender was the centre manager at the time and said that members would get top priority for the limited number of tickets, but everyone attending would get an opportunity to speak to the champion boxer. It was also proposed that the Ali talk-in would be televised nationally.

Mill Garages would provide a cavalcade of ten Mercedes cars for the champion and his wife, family members and close aides, while the remainder of his entourage would be transported by a luxury coach, supplied by National Coaches. Anyone who wanted to make a personal

donation to the charity was asked to direct them to the Westgate Road branch of Lloyds bank, Newcastle upon Tyne.

On 1 July, the organisation committee announced that there would be seven attendants at the marriage blessing. They were as follows:

Twelve-year-old Suzanne Lowe of King George Road, South Shields.
Twelve-year-old Norma Kaid of Marshall Wallis Road, South Shields.
Four-year-old Amanda Jelly of Bideford Gardens, South Shields.
Fifteen-year-old Wendy Walker of Souter View, Whitburn.
Fourteen-year-old Grace Bowering of Gateshead.
Fifteen-year-old Tina Stanley of Newcastle.
Fourteen-year-old Helen Waitt of Newcastle.

Invitations to take part in the Parade of Champions went to the following past and present British boxing champions throughout the country (not all invitees would attend and Floyd Patterson's appearance never materialised). They were as follows:

John Conteh (ex-world light heavyweight champion – as he would be stripped of his title in May 1977).
Terry Downes (ex-world middleweight champion).
Chris Finnegan (ex-British Empire & Commonwealth, European light heavyweight champion).
Kevin Finnegan (British middleweight champion).
Alan Minter (reigning European middleweight champion).
Richard Dunn (ex-British, Commonwealth & European heavyweight champion)
Terry Spinks (ex-Olympic champion and ex-British featherweight champion).
Bobby Neil (ex-British featherweight champion).
Johnny Clayton (ex-Southern Area lightweight champion).
Howard Winston (ex-British, European and World featherweight champion).
Alan Rudkin (ex-British Empire & European bantamweight champion).
Albert Hillman (ex-Southern Area light middleweight champion).
David 'Boy' Green (reigning British & European light welterweight champion).
Vic Andreetti (ex-British junior welterweight champion).

(Parade of Champions Programme)

8

PROBLEMS, PROBLEMS

Even before the invitations were sent out, problems started to besiege the planned extravaganza. First, the sponsor who had agreed to foot the bill for Ali and his entourage to fly over to the UK pulled out. This was a massive blow to the organisers. One possible reason for the withdrawal may have been that Ali was not only planning to arrive with his wife and daughter, but also a group of twelve others (fourteen in total). Without a sponsor, the committee would be left with the transportation costs themselves, which would ultimately have a major financial effect on the final amount raised. Also, the hoped-for appearance at the gala evening and South Tyneside carnival of Morecambe and Wise, Harry Secombe and John Conteh failed to materialise, and all hopes of Floyd Patterson coming and joining the current champion from the States fizzled out almost at the beginning.

But the proposed fundraiser visit was still attracting a lot of attention in local newspapers and television. Adverts were placed and everyone locally seemed to have at least heard that Ali was going to arrive, although people were still not rushing to buy tickets for many of the planned events.

Dick Kirkup sent out press statements that could only be viewed as desperate pleas for readers to start to believe the publicity that the world-famous boxer was definitely coming. The available tickets had been expected to sell like hot cakes, but this still wasn't happening. It seemed obvious to Dick that people were keeping their money in their pockets until they saw for themselves Ali stepping off a plane at Newcastle Airport. However, Dick expressed his concerns about this, saying he thought a last-minute dash for the limited available tickets would leave many disappointed.

However, it wasn't just the unlikely sight of Muhammad Ali walking down the streets arm in arm with a local painter and decorator that was making people wary of buying tickets. The main fundraising event planned for his

visit would be the Mayfair gala night and tickets were very highly priced. A good seat at the function would cost £50, but back in 1977, for some people £50 was a week's wage and many, including myself, simply couldn't afford it. The £50 ticket prices were for tables on the ballroom floor and the £30 tickets were for people sitting up in the bleachers on a surrounding upstairs balcony. Locally, the high prices may have deterred many from putting their hands in their pockets, but they still received interest from as far away as Boston, USA, where someone reserved twelve £50 tickets.

It's possible that the committee set the gala ticket prices using comparisons of the last gala fundraising event in the city, which was attended by Prince Philip and organised by the Variety Club. Ticket prices on that night were set at a staggering £100, so half that price might have sounded like good value for money, but most people who wanted to see Ali were everyday working folk, not company executives, or those from the city elite that would be attracted by a royal-attended occasion.

Shortly before Ali's arrival, Dick Kirkup knew the increasing costs and seemingly hard-to-sell tickets were going to have a major impact on the final sum raised for the boys' clubs, as bringing the champion and his party over wasn't the only cost involved. Apart from the expense of booking halls for the various planned events, there were also the costs of bringing all the other boxing champions to Newcastle. They all resided in different parts of the country, but organisers still wanted them to attend. It would be the first time ever that so many champions were in the city at the same time and, for the Parade of Champions gala night to live up to its billing, every champion possible was needed.

Some boxers would, of course, pay their own travelling expenses to Newcastle, but there was still the issue of expenses for some of the boxers during their city stay. The financial strain to pull everything together had amounted to more than the organisers had planned for, and Dick raised his mounting concerns, explaining that the loss of a sponsor to fund Ali's trip was matched by spiralling costs.

Dick wasn't the only one to get stressed. All the committee members felt the increasing strain as the long working hours dedicated to the project sometimes ended in disappointment, disagreement and frustration. In many ways they were still fortunate, as they only had Ali's visit to organise. Peter Gillanders and his staff had both the boxing champion's and the Queen's separate events to contend with at Gypsies Green, and the smooth running of both meant working round-the-clock hours to not only organise, but to synchronise both events on different days. As the time neared, it was sometimes a case of one step forward, two steps back.

Thousands of programmes had already been printed for South Tyneside Council, which promoted a host of stars supporting Ali's Gypsies Green carnival. Now that most would not be attending, many people thought that it would only be a matter of time before Muhammad's name was added to the list of no-shows. Again, this was having an adverse effect on selling even the programmes for the event. However, Peter Gillanders remained optimistic, saying that everyone who turned out to the carnival would still be receiving excellent value for money, for the modest 20p entrance fee.

More importantly, the committee hit problems with the proposed exhibition at St James' Park football stadium. The news coming from Chicago was that Ali wasn't planning on lacing on any fighting mitts during his time on Tyneside, so all hopes were dashed. Ali said that he intended to treat his time in Newcastle as part of his honeymoon and wasn't too motivated to climb through the ropes and receive punches, even in a friendly public spar.

So all the optimistic plans to see Conteh and Ali in the ring together unfortunately didn't get off the ground. Besides, Conteh was going through his own problems at the time. In the same month of Johnny's mission to the States, Conteh had disagreements with a fight contract to defend his WBC title against Argentinean Miguel Angel Cuello, which was pencilled in for the following month in May 1977 in Monte Carlo. When Conteh pulled out of the bout, the WBC stripped him of the title. Conteh's problems outside of the ring may well have been one of the reasons he wasn't seen during the Parade of Champions weekend.

Also, even if Ali wanted to take part in any public exhibition boxing, there were very few big local and professional fighters around at the time to climb in with him. Peterlee heavyweight Reg Long was one; Paul Tucker (P. T. Grant) was another at heavyweight, but his career was based in London at the time, along with Durham battler Ralph Green, who boxed at light heavyweight. Most local boxers in the region still competed as amateurs and, in 1977, it wouldn't have been straightforward to allow amateurs and professionals to box each other, even in friendly exhibitions. There were strict rules to deter this, even though special permission could be granted in certain circumstances. Heavyweight ABA finalist George Scott still held his amateur status at the time and wouldn't have his first pro fight until September 1977.

As soon as the committee knew of Ali's intentions not to take part in any boxing exhibitions, they swapped venues for the Parade of Champions boxing night to the small, indoor, 3,000-seat arena called the Washington Sports Centre. The hall was made available by the chairman and directors of Sunderland Football Club and would be used for Ali to

simply walk out an array of British champions into the ring. Some of the boxers, but not Ali himself, would then take part in exhibition bouts.

Prices to see the world champion during his visit ranged from 20p to see him at Gypsies Green stadium, £3.50 up to £10 to attend the Muhammad Ali talk-in at Eldon Square, £5 to watch Ali lead the Parade of Champions out at the Sporting Club of Washington, £6 for the Gosforth Park Hotel Variety Club night, and £30 and £50 to attend the banquet at Newcastle's Mayfair ballroom.

The *Journal* and *Chronicle* newspapers also wanted to do their bit for the charity, intending to sell photocopies of the original front page of their paper from February 1964, which showed the first images on Tyneside of Ali/Clay shocking the world by dethroning champion Sonny Liston. These would be available for 10p at each event Ali attended.

The *Shields Gazette* also ran a competition to win two seats at the gala charity dinner at the Mayfair ballroom and, after Ali's departure, would run a competition for a signed pair of his gloves. Members of the committee kept in touch with Muhammad and his staff by telephone, with most of the details discussed and finalised with Jeremiah Shabazz.

By early July, everything was in place. The air tickets had been sent to Chicago and Jimmy Stanley and Johnny Walker would meet Ali and his entourage at Heathrow Airport on 14 July. The plan would then be to catch a connecting BA flight to Newcastle, where the four-day extravaganza would begin.

One other person in the UK who was not part of the event, but who would be the champion's personal guest while on Tyneside, was a man from Abingdon, Oxford. His name was Paddy Monaghan. Everyone in the UK who even took a mild interest in the life and career of Muhammad Ali knew of Paddy. During the boxer's enforced exile years, between 1967 and 1970, he went out on a one-man crusade through the streets of London and his home town with a huge banner that declared Ali was still the champion, despite the powerful World Boxing Association stripping Ali of his title and holding a series of elimination contests to replace him as champion.

Paddy also collected a staggering 22,224 signatures of protest from people who thought it wrong that Ali's title had been stripped for refusing to take part in the Vietnam War. The Abingdon-based Irishman never received a reply when he sent the protest signatures off to the then US-based boxing authority, but his efforts were personally recognised by the champion himself.

When the two eventually met, they became lifelong friends, with Muhammad giving Paddy an incredible insight into his life and times. Ali never forgot Paddy's unwavering support and they visited each other's

homes many times over the years. One of those times was only weeks after Muhammad's finest win against George Foreman in Zaire, Africa, in 1974. The champion turned up at the front door of Paddy's Saxton Road home to visit his family.

What an honour it must have been for Paddy, in 1972, when Muhammad made him an official cornerman in his fight against Alvin 'Blue' Lewis at Croke Park, Dublin, Ireland, and what a unique experience Paddy must have had when he was part of Ali's entourage in 1974 when Muhammad fought Joe Frazier in the widely publicised return Super Fight II at Madison Square Garden in New York. Paddy had also set up an fan club for the boxer in the early 1970s, which he ran from his semi-detached house and included members worldwide, including superstar footballer George Best.

In 1973, Paddy travelled to Ali's home in then Cherry Hill, New Jersey, and presented him with a neat plaque on behalf of his worldwide fans. On the plaque, the words 'People's Champion' were professionally engraved. The year of Paddy's presentation was a year when Ali wasn't the official champion, after losing points decisions to both Joe Frazier in 1971 and Ken Norton in March 1973.

Muhammad was on the comeback trail when he accepted the People's Champion plaque and promised to return to avenge his defeats to both Norton and Frazier. By the end of the following year, in 1974, Ali's promise came true, as he beat Norton in September 1973 and Frazier in January 1974. The year 1974 ended with Ali's surprise KO of official champion George Foreman to not only confirm his People's Champion status, but to claim the official world title too.

In July 1977, Paddy talked to Muhammad on the phone and arranged to meet at Heathrow Airport on 14 July. Paddy would prepare himself for another Ali adventure.

The last week each year in June on Tyneside is known locally as 'Race Week' as there is a prestigious horse race meeting called the Northumberland Plate that takes place and, up to 2013, an annual visit from a carnival. Locals would call the race meeting the 'Pitman's Derby' and the visiting travelling fair 'The Hoppings'. For countless years in the Hoppings fair a boxing booth was erected. The booth was owned and run by a gentleman called Ron Taylor and he would become well known as the 'king of the boxing booths'. Ron was an ex-Army boxing champion and would stand at the entrance of his booth, drumming up interest for his next daily timed show by offering anyone in the audience cash in hand if they could match their fighting skills with one of his team of house boxers or wrestlers.

This was the case in June 1977, when Ron turned up on Tyneside as normal with his travelling booth on Race Week. His boxing and wrestling show went ahead as planned during the week-long Hoppings situated on the vast green acres of grassland, which just touched the north city centre boundary, called the Town Moor.

Ron couldn't believe it when he was first told that Ali was going to be coming to Newcastle, only weeks after his own fairground show finished. However, his disbelief turned to eager anticipation when he was also told there could be an opportunity for the 'king of boxing' to meet him, the 'king of the boxing booths'.

In 2005, I travelled to Ron's Gloucester caravan home, where he happily recalled his memories of Ali to me over many cups of tea, saying,

'Johnny Walker used to box on my booth. Also, famous boxers such as Randolph Turpin, Freddie Mills and Terry Downs have all been on my booth over the years. On the week of the fair in June 1977, I was having a drink with Jack Powell, one of the organisers of the fair, and Johnny Walker at the Gosforth Park Hotel pub on Gosforth High Street. I was totally unaware that it was planned for Ali to visit Newcastle the following month. Jack Powell then mentioned to me how would I like to have Muhammad Ali come onto my boxing booth, in July? At first of course I couldn't believe what he said. I was just in total disbelief, like everyone else. Jack Powell then turned around to Johnny Walker and asked him to confirm what he had just said. Johnny confirmed it; he said that Ali would be coming to Newcastle in July for four days, raising money for the local boys' clubs. Johnny told me that it was planned for Ali to tour South Shields and my booth could be erected near the planned route, so Ali could make a visit.'

He added,

'Jack Powell told me that Ali's time would be run to a tight schedule and for him to visit my booth would cost £500 for about ten minutes, but all the money handed over would be going towards the boys' clubs.'

At first Ron Taylor said that he didn't think he would be available, since he had commitments to the Durham Miners' Gala on the same day that it was planned for Ali to visit South Shields on 16 July.

Ron continued,

'There had been trouble the previous year at the Durham Gala with drunks, so I thought that it might be better to give that one a miss. I agreed to pay Jack the £500 for Ali to visit my booth on Saturday 16 July. Unfortunately, my wife Lily would miss him on that day, since she would be still be at the opening of the Durham Miners Gala.

'However, I bought two £50 tickets for the Parade of Champions gala dinner at the Mayfair Suite planned for the night of 15 July for my wife and myself.

'Lets face it, I would have paid £5,000 to get Muhammad Ali to come on to my booth.'

(Interview with Ron Taylor, 2005)

One week before Ali's arrival, Ron's booth was temporarily erected at the amusement park on South Shields seafront, with Johnny Walker giving a helping hand. It was only when his booth was finally assembled, with the fighting ring installed, that it sunk in and Ron himself finally believed that the champion was really going to show up.

He expected to quickly sell all his £1 entrance tickets, but the inevitable happened and the slow trend continued with the pre-selling of the majority of tickets. No one took seriously that the king of boxing would turn up to his booth, and he only managed to sell a handful of the hundreds of tickets available in advance. Of course, all that would change when Ali arrived at the amusement park.

Elsewhere, plans were being made for Muhammad to receive gifts when he visited Gypsies Green Stadium. It was planned for Mr John Tighe, then the general manager of Wades Furnishers on King Street in South Shields, who had commissioned a large steel statuette, costing £100, to present this on the carnival day. The sculptor was Ken Rowden from South Shields. The statuette was one of two gifts that John Tighe was planning to present to the champion during his time at Gypsies Green. The other was a Silver Jubilee tray. More interestingly, though, Mr Tighe had also arranged for a special 100 per cent Berger green carpet – the traditional colour of Islam – to be made available free of charge for Ali and his wife to walk from the roadside to the entrance of the mosque on Laygate Lane on the morning of the planned wedding blessing on 17 July.

Mr Tighe said that he hoped the whole town would get behind the event and support the charity. Donations had already started coming in from local pubs and clubs, one example being from Mrs Agnes Peterson of the Pier Hotel, who raised £24 in a pub raffle. Mr Tighe said that his

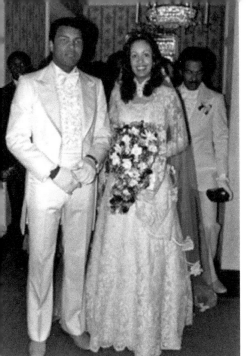
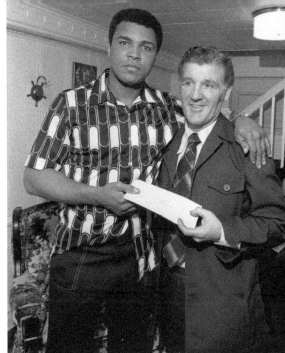

Above left: 1. Ali and Veronica get married on 19 June in Beverley Hills Hotel. (Copyright: Corbis)

Above right: 2. Ali with Johnny Walker in Berrien Springs. (Copyright: *Chicago Sun-Times*)

3. Johnny Walker with Frankie Vaughn at the press conference before leaving for 'Mission Impossible'. (Copyright: Mirrorpix/NCJ Media)

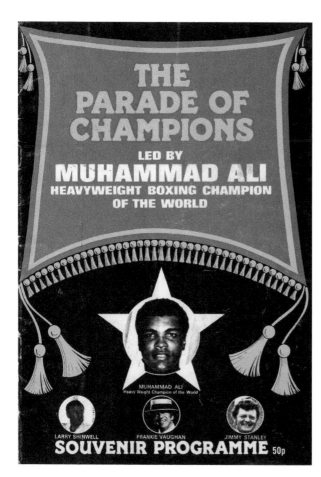

Left: 4. The official Parade of Champions programme. (Russell Routledge collection)

Below: 5. Ali arrives at Newcastle Airport. (Copyright: Press Association)

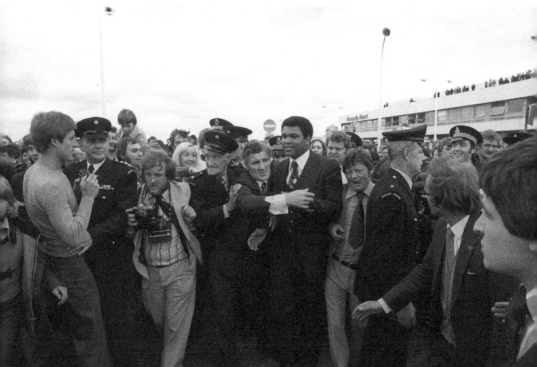

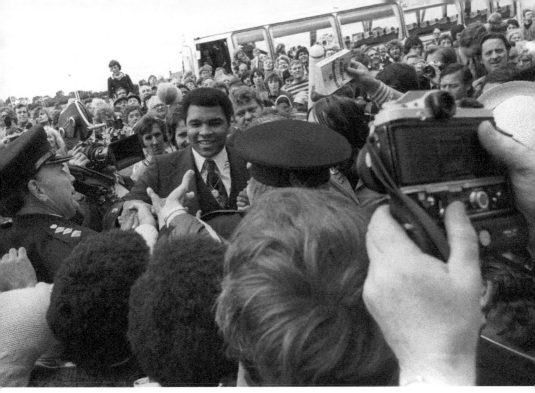

Above: 6. The champion greets fans on his arrival. (Copyright: Press Association)

Below left: 7. Ali meets children's jazz bands on his arrival. (Copyright: Press Association)

Below right: 8. Muhammad carries a majorette on arrival. (Copyright: Press Association)

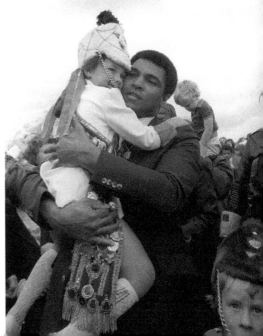

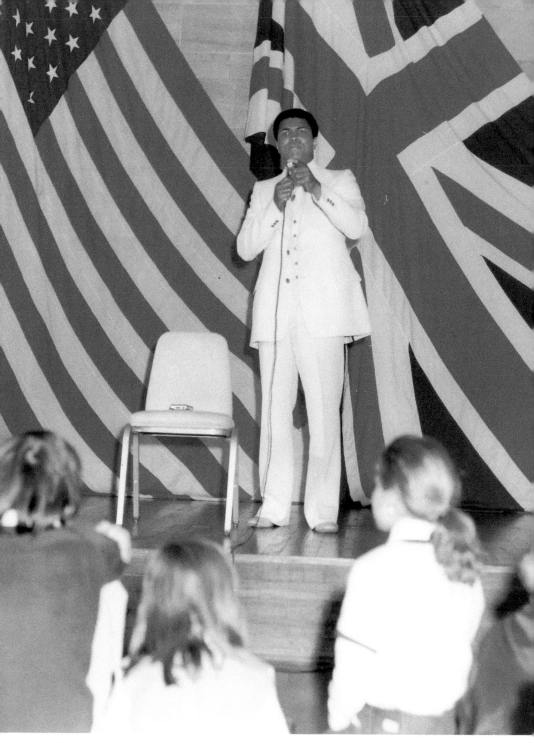

9. Ali delivers his friendship poem before members of the Friendship Force at Newcastle's Civic Centre on 14 July 1977. (Copyright: Newcastle City Council)

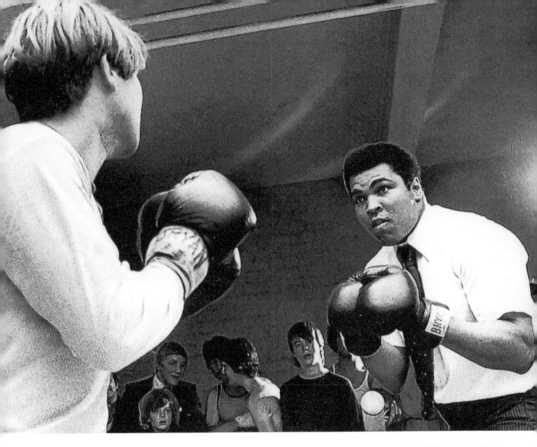

Above: 10. The world heavyweight boxing champion spars with local amateur boxer Les Close at Grainger Park boys' club. (Copyright: Mirrorpix/NCJ Media)

Right: 11. A civic reception invite. (Russell Routledge

Lord Mayor's Chamber
CIVIC CENTRE, NEWCASTLE UPON TYNE. NE1 8QA.

The Lord Mayor and the Lady Mayoress
(Councillor T. W. Collins & Councillor Mrs. M. Collins, JP)

request the pleasure of the company
of you and your partner
at a Reception, to be held at the Mansion House, Fernwood Road
on Friday, 15th July, 1977 at 5.30 p.m. to meet Muhammad Ali,
Heavyweight Champion of the World.

R.S.V.P.,
Lord Mayor's Secretary
& City Protocol Officer,
Civic Centre,
NEWCASTLE UPON TYNE, 1.

LORD MAYOR'S SECRETARY AND CITY PROTOCOL OFFICER
G. N. E. RENDER

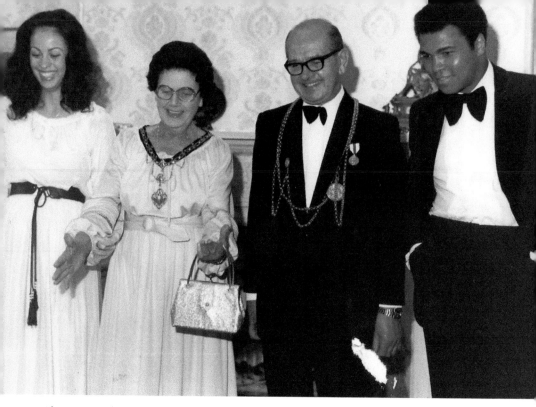

Above: 12. Ali with Newcastle's Lord Mayor and Lady Mayoress at the civic reception. (Copyright: Newcastle City Council)

Below: 13. Taking time out during the civic reception. (Copyright: Newcastle City Council)

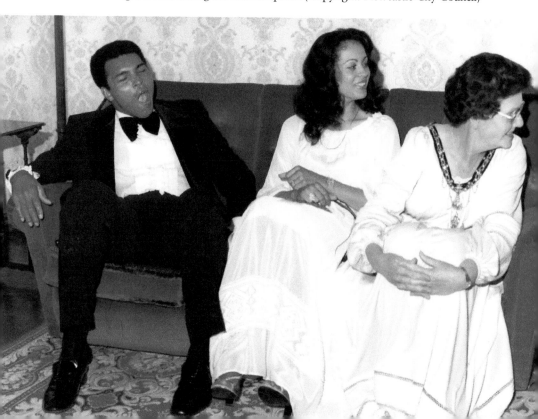

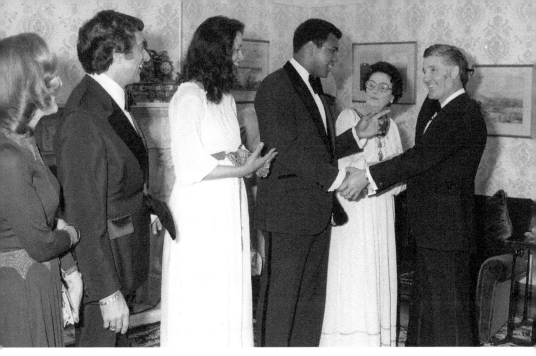

Above: 14. The champion officially greets Johnny Walker at the Newcastle civic reception. (Copyright: Newcastle City Council)

Below: 15. Ali takes his daughter for a stroll through the grounds of the Lord Mayor's civic residence. (Copyright: Newcastle City Council)

Inset: 16. Ali's daughter dressed up for the gala dinner. (Copyright: Mirrorpix/NCJ Media)

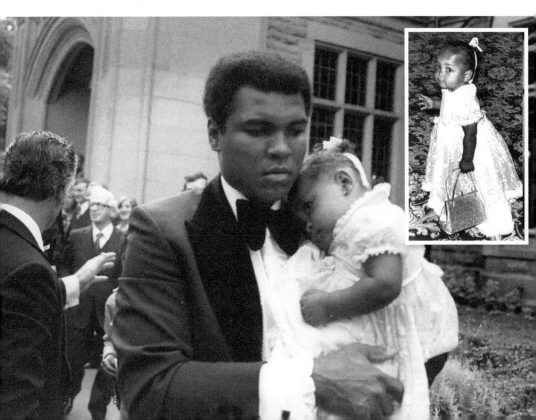

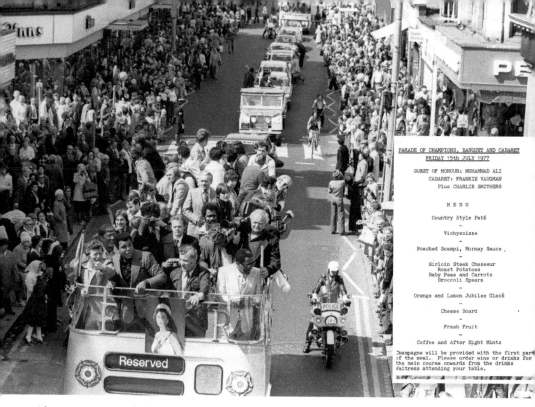

PARADE OF CHAMPIONS, BANQUET AND CABARET
FRIDAY 15th JULY 1977

GUEST OF HONOUR: MUHAMMAD ALI
CABARET: FRANKIE VAUGHAN
Plus CHARLIE SMITHERS

M E N U

Country Style Paté
-
Vichysoisse
-
Poached Scampi, Mornay Sauce ,
-
Sirloin Steak Chasseur
Roast Potatoes
Baby Peas and Carrots
Broccoli Spears
-
Orange and Lemon Jubilee Glacé
-
Cheese Board
-
Fresh Fruit
-
Coffee and After Eight Mints

Champagne will be provided with the first part
of the meal. Please order wine or drinks for
the main course onwards from the drinks
waitress attending your table.

Above: 17. Crowds line the streets as Ali rides in the Queen's Jubilee bus. (Copyright: Press Association)

Inset: 18. The Parade of Champions gala dinner menu. (Russell Routledge collection)

Below: 19. Ali waves to fans as the bus drives along. (Copyright: Press Association)

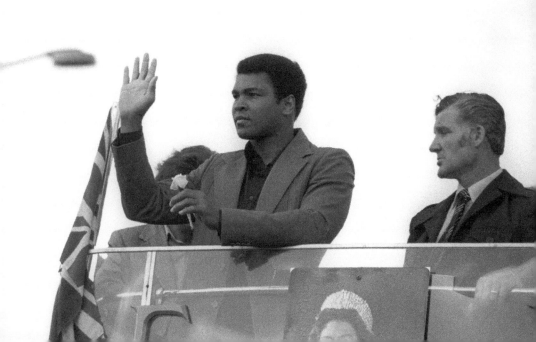

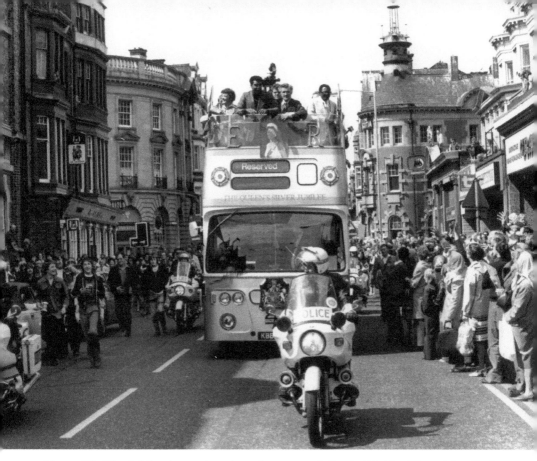

Above: 20. The Jubilee bus going through streets of South Shields. (Copyright: Fred Mudditt of Fietscher Fotos Ltd, South Tyneside Libraries)

Below: 21. Ali on the Jubilee bus with Jimmy Stanley (*left*) and Johnny Walker (*right*). (Copyright: Press Association)

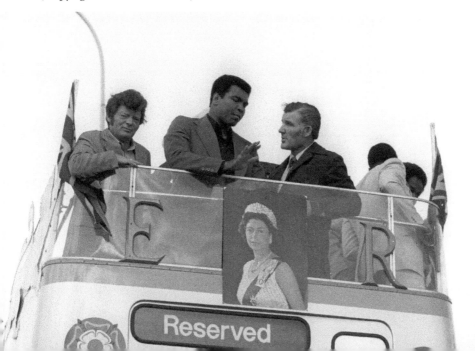

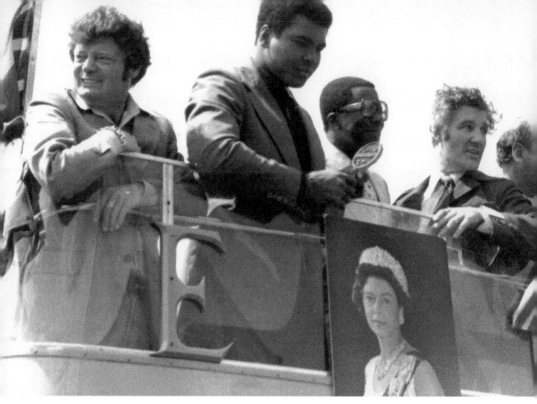

Above: 22. Muhammad Ali, Jimmy Stanley and Johnny Walker on the Queen's Jubilee bus. (Copyright: Fred Mudditt of Fietscher Fotos Ltd and South Tyneside Libraries)

Below: 23. The Jubilee bus rides through the streets of South Shields. (Copyright: Fred Mudditt of Fietscher Fotos Ltd and South Tyneside Libraries)

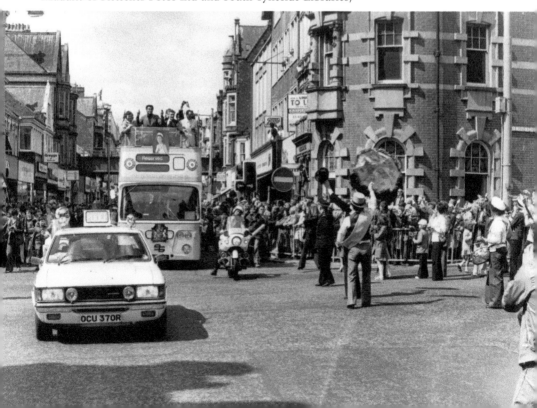

Above: 24. The champion is mobbed by fans in South Shields. (Copyright: Fred Mudditt of Fietscher Fotos Ltd and South Tyneside Libraries)

Below: 25. Ali arrives at Gypsies Green Stadium on 16 July 1977. (Copyright: Fred Mudditt of Fietscher Fotos Ltd and South Tyneside Libraries)

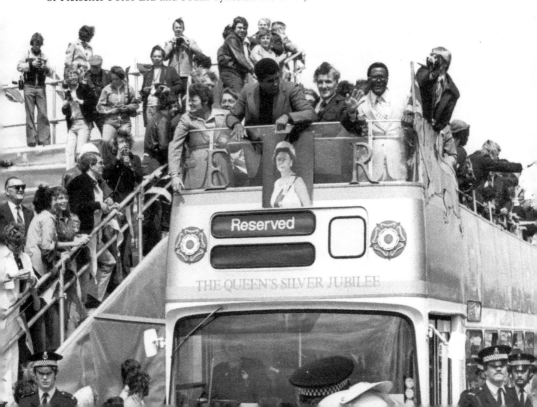

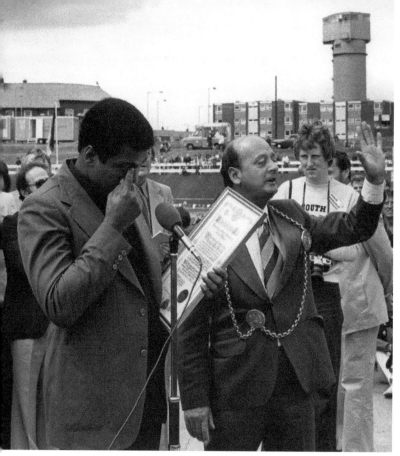

Left: 26. Ali receives a Scroll of Honour from the Lord Mayor of South Tyneside. (Copyright: Fred Mudditt of Fietscher Fotos Ltd and South Tyneside Libraries)

Below: 27. Ali and Johnny Walker greet crowds at Gypsies Green Stadium in South Shields. (Copyright: Fred Mudditt of Fietscher Fotos Ltd and South Tyneside Libraries)

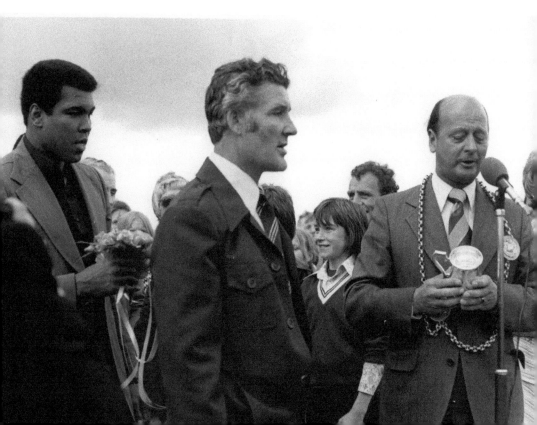

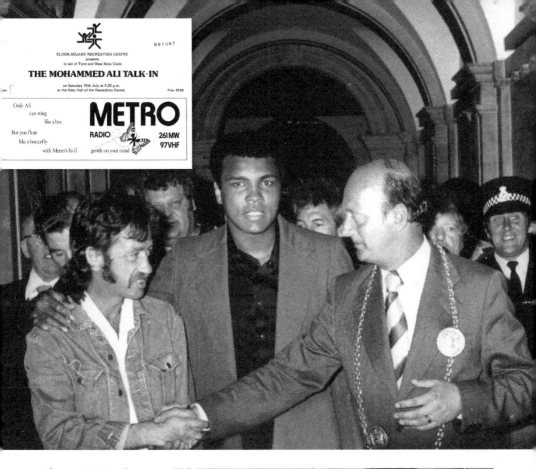

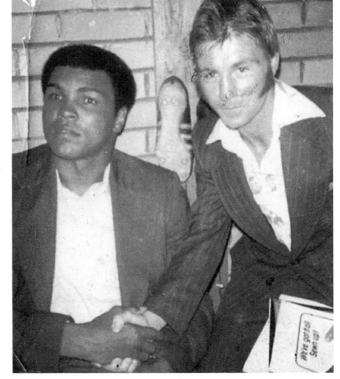

Above: 28. Lord Mayor Seth Robinson shakes the hand of Paddy Monaghan. (Copyright: Fred Mudditt of Fietscher Fotos Ltd and South Tyneside Libraries)

Inset: 29. An entrance ticket for the Ali talk-in at Eldon Square. (Russell Routledge collection)

Right: 30. Ali meets local boxer Alan Robertson before the exhibition bouts at Washington Sports Centre on 16 July 1977. (Alan Robertson collection)

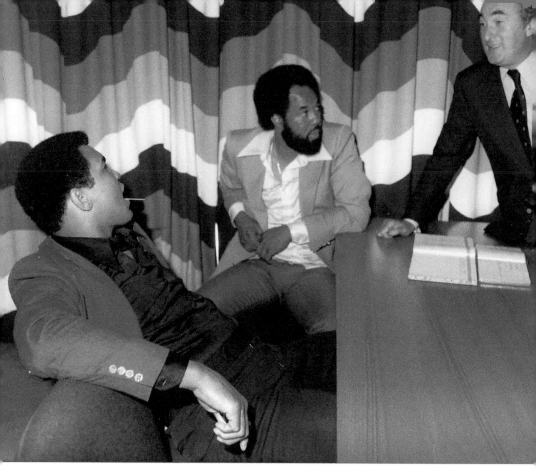

Above: 31. Ali talks with big time promoter Jarvis Astaire before the talk-in at Eldon Square. (Copyright: Newcastle City Council)

Below: 32. Muhammad and Veronica stand in the crowded prayer room at South Shields Mosque. (Copyright: Press Association)

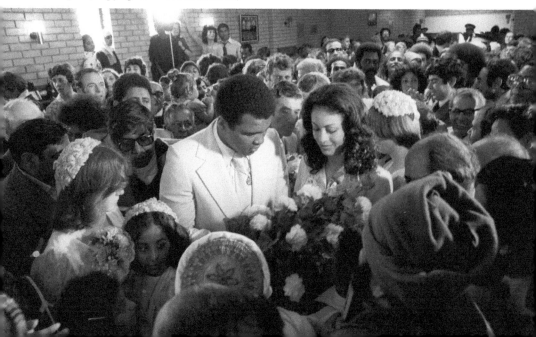

33. Ali and Veronica in the South Shields mosque. (Copyright: Press Association)

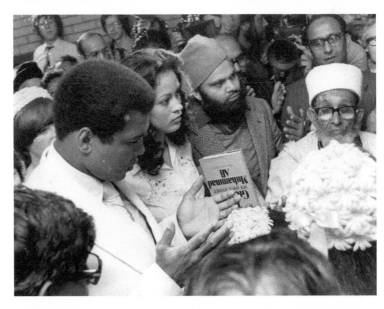

34. The champion and his wife during the ceremony. (Copyright: Fred Mudditt of Fietscher Fotos Ltd and South Tyneside Libraries)

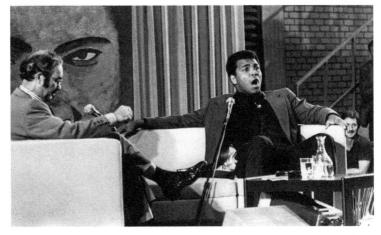

35. Ali with Reg Gutteridge at the Eldon Square talk-in. (Copyright: Mirrorpix/NCJ Media)

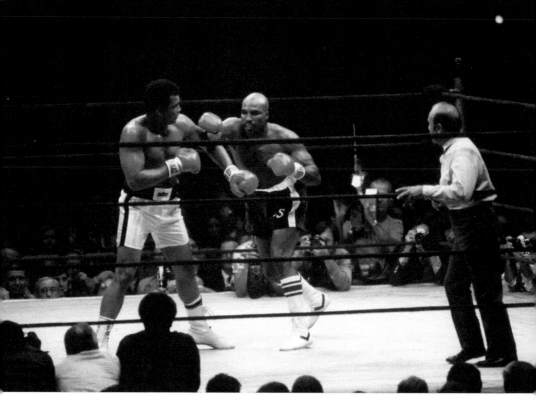

Above: 36. Muhammad Ali meets Earnie Shavers at Madison Square Garden in his next fight after leaving Newcastle. (Copyright: Press Association)

Right: 37. Ali greets crowds outside of the mosque on 17 July 1977. (Copyright: Mirrorpix/ NCJ Media)

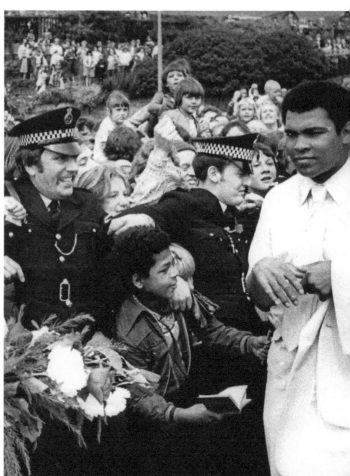

company would be making a £50 donation and hoped other businesses would also donate.

The fine details of Muhammad Ali Day in South Shields were finalised, with the town's own thirteen-piece Heritage Brass Band assisting the parade to South Shields seafront. They were modelled on jazz bands of the Southern States of America, bringing a familiar sound to the world heavyweight champion.

However, the majority of ticket selling was difficult right up to Ali's arrival, but one event that had sold out before Muhammad even had left the States was the dinner organised by members of the Tyne and Wear Committee of the Variety Club of Great Britain, set for Ali's first day on Tyneside at the Gosforth Park Hotel. However, proceeds from his first official engagement wouldn't be channelled into the boys' clubs fund, but to local handicapped and underprivileged children, with the Variety Club already agreeing to donate £4,000 towards a Sunshine coach for the local Pendower School for the Handicapped.

It was also hoped that Muhammad would appear on the day of his arrival on Metro Radio, as a special guest on Kevin Rowntree's afternoon talk show at the studio's base at Swalwell, Gateshead. In tribute to Greatest, Tyne Tees Television also rearranged their programme schedule to show a documentary about the champion's life called *Skill, Brains and Guts* on Friday 15 July.

ALI'S FIGHT FINALISED

Shortly before Ali's departure from Chicago, the court battle between the management of Madison Square Garden and Bob Arum's Top Rank Inc. had finally come to a conclusion. Madison Square Garden came out on top and had won the exclusive right to promote the Ali *v.* Shavers bout, which would take place on 29 September 1977 and be televised live by NBC television. Ali would receive £1.8 million ($3 million) plus £120,000 expenses for his nineteenth title defence, and Shavers would receive ten times less, but still his highest purse of his career, a cool £180,000 ($300,000) plus £6,000 expenses.

Earnie, who was born in the same state as the legendary 'Brown Bomber' Joe Louis, in Alabama, but later moved and based himself in Ohio, was ranked as the No. 4 heavyweight in the world and possessed a higher knockout percentage than all other past heavyweight champions (96.3 per cent). He would be thirty-three years old (date of birth 31/08/1944), and this would make Shavers two years younger than the current champion going into the bout. A confident Shavers relished the opportunity of facing the older champion in the Mecca of boxing, Madison Square Garden.

The choice of venue was ominous for Muhammad as he took part in some of his most memorable but certainly hardest fights there. The Shavers title bout would be the first World Heavyweight Championship fight held there since Ali suffered a devastating knockdown and loss against 'Smokin' Joe Frazier in 'The Fight of the Century' six years previously in 1971. He also received his first knockdown in Madison Square Garden as a pro in 1962 against Sonny Banks (the old Madison Square Garden) before rallying to stop his opponent in the fourth round. Ali was well out with his prediction at his next Garden appearance in 1963, when he quoted six rounds to

beat Doug Jones in 1963, but only managed to squeeze a hard-fought and disputed ten-round points decision win.

It was also in Madison Square Garden that he had a tough and bruising encounter with the rugged Oscar Bonavena in 1970, before finally scoring a stoppage in the fifteenth and last round.

Muhammad did have easier fights there, though, knocking out Zora Folley in 1967 and stopping Floyd Patterson in 1972; also winning his return bout with Joe Frazier on points in 1974. The winning return bout with Frazier was the last time Ali fought there. Shavers' last bout at the famous main arena was a losing one, when he was blitzed in one round by 'Irish' Jerry Quarry in 1973 (Shavers fought at the small theatre under Madison Square Garden, then known as the Felt Forum, on 4 November 1974, but again came away a loser, dropping a points decision to Bob Stallings).

One week before Ali left the States (8 July 1977) to enjoy his 'second honeymoon' on Tyneside, he turned up in Marquette, North Michigan, to help raise funds for the North Michigan University (NMU). It was the fulfillment of a promise he had made earlier in the year to help a scholarship fund for the university. On 9 July 1977, Marquette celebrated Muhammad Ali Day, where he addressed a crowd with one of his many memorised and self-composed speeches called 'The True Meaning of Friendship'. This was the same poem that Ali had once recited at one of the top universities in the world, Harvard University in Massachusetts.

While in Marquette, the champion also boxed a four-round exhibition with his long-time sparring partner Jimmy Ellis, with all the gate receipts going towards the fund. It was also during his stay here that Ali had a surprise meeting with his first-ever amateur boxing trainer, Louisville policeman Joe Martin.

Interestingly, 9 July 1977 meant that the champion's next real ring opponent, Earnie Shavers, was already two days in from his initial physical preparations for the biggest fight of his life. Shavers based his training camp in his home state of Ohio, under the watchful eye of fight trainer Frank Luca. Ali's charitable commitments and international travel plans at this time may well have been sweet music to Earnie's ears and would only boost his chances in their upcoming fight.

Despite Shavers' shaven-headed, mean-looking appearance, he really was a good-natured guy, who had always liked and respected Ali as champion. He had never forgotten the generosity the champion had shown him in 1973, allowing him to use his Deer Lake training camp. During Earnie's spell there, a story came out in the press via Don King that Ali had actually booted Shavers out after being floored by the big puncher in a sparring

session. Later, the 'knockdown' and 'booted out' stories were claimed only to be publicity stunts and, years later, Earnie would openly state that he never actually exchanged punches with Muhammad during his 1973 camp stay. But despite Earnie's respect and fondness for Ali, he ominously warned of the risks and danger of turning up in the ring anything less than 100 per cent prepared. Shavers' reputation was earned: he had stopped forty of his fifty-two knockout victims before the fourth round.

Shavers had already signed for the fight; however, because of the champion's film and charity commitments, and naturally wanting to spend time with his new bride, finding time for Ali to finalise the contract was delayed until after he returned from Tyneside.

Prior to Ali's US departure to Newcastle, he confirmed he would be appearing at a £50 per head benefit dinner and was looking forward to the surprise on people's faces when he arrived. Ali spoke about how it would be an honour and pleasure to be on Tyneside at the same time as the Queen of England, and reiterated his intentions not to lace on the gloves to box any exhibitions while there. However, he then landed a bombshell when he declared that he *wouldn't* be having his wedding blessed at the mosque in South Shields.

Muhammad stated that he didn't want to put his wife 'on display' and didn't want to go through another public ritual. On the other side of the Atlantic, Johnny remained tight-lipped about Ali's apparent change of heart, but the blessing had already been organised and formally agreed with his management. The organisation committee would have treated the boxer's statement as confusing to say the least. Mr Muhammad Kaid, secretary of the Laygate Lane Mosque, expressed his disappointment on first hearing the sudden change of plans, but still hoped that Ali would perhaps visit the mosque while he was in South Shields, saying that he would be more than welcome.

As the hours counted down to the arrival of the Greatest, everything appeared to be in place. Even though many still found everything hard to believe, reality was starting to sink in, and it looked like Muhammad Ali was really coming.

Rumours had spread fast, especially throughout the local boxing community, one being that the champion might even turn up at Grainger Park boxing club, based on Armstrong Road in Scotswood. This was the same club that I sometimes frequented as a youth in 1977 and I was taken in by all the rumours and publicity going around, but the 50p official programme had no mention of Ali visiting any boxing clubs, so even though rumours raged, many, including myself, remained sceptical.

ALI IN TYNESIDE

Ali Arrives (14 July)

On the morning of 14 July, Jimmy Stanley and Johnny Walker were at Heathrow Airport in London waiting to greet Ali and his entourage from Chicago. The plan was for them all to catch a British Airways flight and arrive in Newcastle Airport at 10.55 a.m.

At the same time, in Newcastle, buses transported seventeen youth jazz bands to the entrance of the airport, where a special welcome was planned for Muhammad and his family on his arrival. Television cameras were set up on the lawns and bands started their practice routines, with everyone's eyes following the air approach of each plane that came in overhead.

A crowd of over 1,500 people had gathered, including some of the invited British boxing champions from around the country, who mingled in with the crowd. As each plane landed on the tarmac, the jazz bands struck up a tune, but each time a plane taxied up to the terminal, Muhammad Ali was nowhere to be seen.

In Heathrow Airport, Jimmy and Johnny had already received the news that Ali's TWA flight from Chicago was running thirty minutes late. With a more-than-tight schedule in place, this meant there would now be a frantic rush to catch the connecting flight to Newcastle. There was nothing Jimmy or Johnny could do but inform fellow committee members back in Newcastle of the news. The hope was that they would all still make the arranged connecting flight, with some help from airport officials and BA flight personnel.

Eventually, the TWA flight carrying Ali and his party arrived, but any special permission they hoped to obtain from customs and immigration staff to bypass or speed up their landing procedures was refused.

Unfortunately, they had to go though all the time-consuming border checks before they could continue onward.

This added time to the already thirty-minute delay and, when the Ali entourage finally came through and were greeted by Jimmy and Johnny, they had unfortunately missed their connecting flight, despite a mad dash through the terminal to reach the departure gate. To the disappointment of everyone, the BA flight hadn't waited for them and had already left. There was more bad news – all other flights to Newcastle were full.

An already travel-weary Ali wasn't a happy chap that morning, saying that the flight shouldn't have left without him, because he came here for a good cause. Airport officials countered his reasoning by saying it would have been unfair to other passengers to hold the BA flight up. On this occasion though, I feel many on board would have been more disappointed that they had left without the famous fighter, as it surely would have been a flight to remember.

In London, during the delay, Ali told reporters that not many film stars would do what he was doing by coming all this way, without a large fee attached, but he wanted to help people, so he made the long trip to help the kids of Tyneside. Big fights, fame and fortune were not what God would judge him by, but only on what he did for humanity and society. That's why he was here for Johnny Walker.

Paddy Monaghan and a few close friends of the champion joined him here and the organisers informed Muhammad of the revised plan to get his travelling party to Newcastle. It would mean they would have to take a British Midland flight to Teesside and then drive the remaining 40 miles to Newcastle. This would mean more delays before his arrival on Tyneside.

To pass the time, Ali spoke about his next fight against Ernie Shavers. He said the man everyone was calling a 'knockout specialist' still wouldn't beat him, despite being thirty-five years old and close to retirement.

Speaking about the charity event in Newcastle, Ali reiterated his intentions of not lacing on the gloves to spar with any of the boys while there, but said he was looking forward to meeting everyone in Newcastle and Johnny's home town.

Back at Newcastle Airport, the expected time of arrival, 10.55 a.m., had long passed and there was now an air of despondency, with most starting to believe that Ali wasn't going to show up at all. Rumours started spreading, with the result of the welcoming bands not bothering to burst into tune on the sight of each approaching plane. Instead, the tunes and excitement were gradually replaced by moans and groans.

It was a long while before the news of the champion's later than expected arrival filtered through to everyone in the crowd, but on hearing

the change of plans, most of the assembled press and television people made a beeline down to Teesside Airport. They wanted to be there to catch Ali's arrival, but it didn't take long for the news to quickly spread in the airport that Muhammad Ali would be turning up unexpectedly. Locals and airport staff started to gather in the terminal in the hope of catching sight of the famous boxer.

On board the short flight, Johnny Walker somehow used his persuasive charm yet again on Ali, reassuring him about the planned, then cancelled, wedding blessing. The charm must have worked because, before the plane touched down at Teesside, the champion had a change of heart and confirmed that the blessing could proceed as planned.

On the afternoon of 14 July, the British Midland flight finally docked at Teesside Airport, with Ali leaving the plane alongside Johnny Walker and Jimmy Stanley. As Muhammad set foot on the tarmac, with baby Hana in his arms, he was besieged by waiting reporters, with most wanting to hear confirmation of the cancellation of the wedding blessing. He took everyone by surprise again when he said the blessing could now go ahead. Ali's change of heart would have been to the delight not only the people of the mosque, but also to the members of the committee.

Reporters were also quick to inform Ali that most people on Tyneside thought that he wouldn't come. He said that he really enjoyed surprising people and it was understandable that most people refused to believe that Johnny Walker would bring Muhammad Ali to his home town. Questions came flying in regarding what he thought about being in Tyneside at the same time as the Queen of England. The boxer told everyone that he had met the Queen of England in Washington DC the previous year, but hoped to see her while in the North East too. He also told the press that he was looking forward to meeting everyone at Newcastle Airport and hoped everyone would support the charity.

Ali and his wife were then whisked off in a cavalcade of Mercedes cars, with a luxury bus laid on for other members of his party. They were transported up the A19 en route to all the waiting fans in Newcastle. When the car cavalcade finally pulled into Tyneside's International Airport entrance, they were three and a half hours late, but Ali arrived and all the doubters were proved wrong. Johnny Walker had achieved what everyone said was impossible. He had brought the Greatest to the North East.

When Ali's car came to a stop outside the terminal building, applause rose up through the crowd and masses of people started to press forward as the champion left his car and made his way up to where the children's bands were waiting. They struck up a tune and the crowd swelled as

everyone pushed forward. Among the mayhem, photographers, reporters and fans alike jostled for position, as airport police officers' hats were knocked askew, trying in vain to keep order within a sea of excitement.

Jimmy and Johnny attempted to stay by Ali's side as they squeezed through the crowd towards the children. The champion, famously known to cause pandemonium on public walkabouts, found it no different here, as a couple of minor scuffles broke out between those trying to get closer, but a mass of Geordie faces surrounded Ali, who just happened to be the most relaxed person of everyone there, as he gently picked up random children from the bands, giving them a hug or kiss. Seven-year-old majorette Michelle Scott was scooped up by Ali that afternoon and memories of those brief few minutes in the arms of the champion have stayed with her to this day, some thirty-seven years later.

I was another one of the fans there that summer's afternoon, with my outstretched mitt, reaching through a thousand others, just managing to briefly touch the hand of the Greatest. Eventually, though, Ali was guided through the chaos back to the airport terminal where a hoard of press were waiting.

Although Ali was clearly tired and subdued from the long transatlantic flight and botched flight transfer, it didn't stop him talking about his next opponent or heaping praise on Johnny Walker for convincing him to come across the Atlantic to help boys' clubs. He said that he didn't really have the time to come, but accepted Johnny's invitation because he believed it was his mission to help and bring people together.

The champion also remarked on the tumultuous reception he had just received from both fans and children, saying that it equalled the type of welcome that he received in many Muslim countries and he was just happy to have eventually made it here. There were smiles all around when Ali made statements about two prior decisions he made in Chicago. Firstly, the wedding blessing in South Shields was back on, and secondly, he *would* agree to take part in some friendly sparring exhibitions while on Tyneside. Johnny was the 'boss' while he was here and if he wanted him to spar with some of the local boxers, he would do it, but there would be one condition attached: that one of the rounds would be against Johnny Walker himself. 'You've got a deal,' said former amateur boxing champion Johnny Walker.

So all plans of Ali only leading fellow champion boxers out into the ring at the Washington Sports Centre on Saturday night could now be changed to include the heavyweight champion swapping punches with them. This was great news for both fans and organisers alike, but they wouldn't have

too much time to promote Ali actually lacing on the gloves, as the Parade of Champions boxing night was only two days away.

After the press conference, Muhammad and his family were squeezed through the crowds back into the waiting car and whisked off to Turner's photographers on Pink Lane, in Newcastle city centre. Staff photographer Ken Pope shot a batch of formal photographs of Ali and his wife and daughter in the studio. Pictures were also taken of him with other members of the organising committee. One photograph of his daughter would later be presented to Veronica, and a special photograph of the champion, which Ali would sign, would be sold in the charity auction at the gala dinner set for Friday night at the Mayfair ballroom.

Afterwards, as Ali and his wife walked out of the photographic studio, they were besieged by a wall of waiting fans and well-wishers, who had spotted their cars. The champion exchanged banter with them, saying that he didn't realise he had so many fans in this part of the world. The Ali party was then taken to the Holiday Inn at Seaton Burn for some much needed rest. Both Johnny and Jimmy had rooms next to the champion's suite.

Muhammad's late arrival meant a planned radio talk-in at the Metro Radio Studios in Swalwell was postponed. At first, he agreed to be interviewed at the hotel itself, and members of the local radio station rushed up to the hotel with an outside broadcasting unit, but time restrictions prevented the broadcast from taking place.

Also, by coincidence, on Ali's arrival at the Seaton Burn hotel (14 July) another notable US citizen was already booked in. He was from the place of the boxer's much heralded comeback to boxing in 1970: Atlanta, Georgia. That person was Revd Wayne Smith, the founder of the Friendship Force scheme, which the Tyneside folk first heard about during President Carter's visit to Newcastle earlier in the year.

The 381 US Friendship Force guests had arrived on 5 July and they would be returning home to the States the day after Ali's arrival (15 July). Revd Smith and his family checked into this hotel on their last day on Tyneside, as it was in close proximity to their place of departure the following morning, Newcastle Airport.

Revd Wayne Smith couldn't help but notice all the fuss and commotion one new arrival was causing that late afternoon, and was totally surprised when he found out it was none other than his fellow countryman, Muhammad Ali. His surprise was matched by the hope that he would somehow be given an opportunity to speak to the champion before he checked out of the hotel the following day.

When he found out that Muhammad Ali was staying only a few rooms along the corridor from himself, Wayne managed to pass a written note to Ali's room, which explained who he was and what the international friendship programme was all about. He wrote that the American and British Friendship Force contingent would be more than pleased to see him at the farewell dinner starting in a few hours' time at Newcastle's Civic Centre. To Wayne's surprise, Ali not only got to read his message, but invited him to the champion's room.

This meeting was the start of a long personal friendship, as Ali liked the concept of Wayne's Friendship Force. Muhammad told him that friendship was something very close to his heart and that he had recently publicly recited his poem about the 'meaning of true friendship' while back in the States. To Wayne's delight, the boxer agreed to make a surprise visit on their last night, but only if he could recite his own friendship poem to everyone at the farewell dinner.

Ali's promise of appearing later that night would be more than a grand finale to the first-ever international friendship scheme, as it would be a major scoop for Wayne Smith himself and a huge surprise for those attending the Civic Centre that night. With each passing year, the network of people involved in the Friendship Force programme would expand and become more popular. Today, it has over 300 clubs in sixty countries around the world, with thousands of people participating internationally.

After a short rest at the hotel, Ali was driven to one of the clubs that the charity was aiming to help, West End boys' club. The boxing section was run by an ex-boxer and much loved and respected local character, Phil Fowler. Phil received the surprising news that the world heavyweight champion would be visiting them at short notice, so the boys just managed to place a large ad hoc hand-painted sign on the back wall behind the small raised boxing ring to welcome the champion boxer.

Muhammad Ali entered through the same gym doors that hundreds of young lads had entered over the years while searching for their own pugilistic glory. Amateur champions such as Tommy Gordon, George Scott, Paul Tucker (pro name P. T. Grant), Larry Ritson, Terry Baldwin, John Westgarth, and later John Davison had all come through these same doors to be guided by Mr Fowler.

That night in 1977, young boxers Clive Gibson, Bobby Allan, Steve Beaumont and others were busy training when Muhammad Ali entered. The boys stood wide-eyed as the world heavyweight champion strode in. Bobby Allan, a teenage welterweight at the time, later recalled to me the moment when the Greatest paid them a visit. He said,

'I had been training in the ring before Ali came through the door. I was sweating and left the boxing ring, looking in one of the mirrors in the gym. The next thing I knew Ali came through the door and came straight over to me, putting his hands on my shoulders and resting his chin on my head. We were both facing the mirror and then Muhammad asked if I thought I was as pretty as him.'

(Interview with Bobby Allen, 2005)

Clive Gibson was a small-framed seventeen-year-old at the time and wasn't too keen on being the centre of attention, but it all changed that evening when he came face-to-face with the heavyweight champion. Ali raised his famous mitts and asked the young kid to jab at his hands and show him some of his boxing moves. Clive shot jab after jab at the champion's open hands and afterwards received some advice from the Greatest. Ali, who towered over the young boxer, leant down and told him that speed was the key to ever becoming a successful boxer.

The statement in Chicago about not sparring with any of the youngsters now seemed to be long forgotten and presumably special permission was already granted for the pro-am session. The heavyweight champion walked towards the elevated boxing ring, which was pressed into a concave of the room, climbed up the old wooden steps, and slipped through the ropes into what could be described as his workplace, where he had earned both fame and fortune over the years.

Ali didn't bother donning any boxing gloves and was still suited up, with a gold medallion hanging around his neck, as the lads lined up, each ready to take their turn swapping punches with the Greatest. Muhammad danced, jabbed and clowned his way through some playful fisticuffs with a string of keen pugilist pupils. Phil Fowler acted both as referee and motivator for the kids as Ali gave them something they would remember for the rest of their lives.

One opponent was fourteen-year-old Steve Beaumont. Steve, then weighing a touch over 7 stone, faced the world heavyweight champion. The young nipper moved forward to try and catch the champion with his clenched fists, while Phil did his bit urging the boy boxer on, to try and tag the champion. The famous 'Ali shuffle' followed, with all the boxers in the gym cheering, as Steve kept slinging punches.

Muhammad stayed in the gym for about thirty minutes, sparring and chatting to the boys and watching them go through their fitness routines. He signed autographs and posed for pictures and also took time to visit

the main section of the boys' club, meeting everyone before he and his travelling party eventually returned to the awaiting cavalcade of cars.

From the West End boys' club, the champion fulfilled his promise to Revd Wayne Smith and made an appearance at the nearby Civic Centre to meet all the Ambassadors of Peace from Atlanta and Newcastle. Ali instructed the organisers that he wanted 'just twelve minutes' to say his own farewell to them.

Ali's surprise trip to the Civic Centre that night was more than a touch disappointing for me, though, as I had spent the whole previous day helping prepare the banqueting hall for the farewell dinner that Ali was surprisingly going to attend. It was after doing this preparation work that I was given special time off from the Friendship Force team to try and locate my boyhood hero. Without myself or any one of my work colleagues being aware, Muhammad Ali was about to visit the place I had been trudging back and forward to for the past two years.

When I returned to work the following Monday morning from my 'must find Ali on Tyneside mission' and opened the office door to the news that he had been just along the corridor while I was away on my personal search, I spent all day in disbelief, and it wasn't until much later, when someone handed me a photograph as final proof, that I believed he had been there.

At 9 p.m., in the banqueting hall, all the diners were interrupted by a surprise announcement. Wayne Smith stood on stage and told everyone that a special guest had just popped by to say hello, but his guest wouldn't need any introduction as everyone, no matter which country they came from, would instantly know who he was. Wayne then welcomed the world heavyweight champion onto the stage and, to the surprise and delight of everyone in the room, Ali walked out. Surprise soon gave way to thunderous applause and a standing ovation as the champion stood between two full-size flags: one the Union Jack, the other the Stars and Stripes. Ali took the microphone and thanked everyone for the welcome, then delivered his rhymed poem about the meaning of true friendship. Time was short, but afterwards he spoke about the need for peace in the world, before answering questions from the hall full of people, and finally being ushered away to his last engagement of the day.

Amazingly, the Seaton Burn Holiday Inn became the catalyst for Ali and Smith becoming lifelong friends. When they both returned to America they would meet regularly to discuss their shared interests of religion and friendship and the boxer would eventually join the advisory council of the international scheme.

Later in 1977, the champion would return to Revd Wayne Smith's home city of Atlanta, known famously as the city 'too busy to hate'. His visit would be seven years to the exact month after fighting there for real back in October 1970. On 13 October 1977 Ali took part in a friendly four-round fundraiser against Jimmy Ellis to help raise money for the Friendship Force. The bout took place at the Omni Hotel, with the champion also surprisingly handing out invitations to anyone in the crowd who dared go a round with him.

The Friendship Force, with its links to Muhammad Ali, President Carter and Revd Wayne Smith, would stand the test of time. Jimmy Carter would come to Newcastle ten years later to mark the tenth anniversary of the inaugural exchange scheme, celebrating American Independence Day there on 4 July 1987. In 1996, the former champion would return to to Carter's home city to light the flame to start the Atlanta Olympics. In 1997, Ali, President Carter and Revd Wayne Smith would also be together to celebrate the twentieth anniversary of the Friendship Force in Atlanta, with Ali receiving an award from Wayne Smith for his many achievements.

Jimmy Carter, who would go on to become the first US President to receive a Nobel Peace Prize in 2002, would also be honoured in Ali's home town, Louisville, Kentucky, on 3 October 2013, where he would receive the inaugural Muhammad Ali Humanitarian Award at the Galt House Hotel. Although the then eighty-nine-year-old former US President couldn't attend, his award was graciously received by the President's son, Chip Carter, who called Ali a family friend.

Back in Newcastle in 1977, Ali's brief stop-off at the Civic Centre meant that it was a late arrival at the Gosforth Park Hotel for the sold-out Variety Club charity dinner in aid of local handicapped and underprivileged children. When Ali turned up at the entrance, waiting for him among a host of other greeters was twelve-year-old fan Ian Pleasant, who presented a polystyrene home-made butterfly to his hero.

Inside, Ali was greeted by pipers as the diners applauded his entrance. Champions Alan Rudkin, Chris Finnegan, Kevin Finnegan, Vernon Sollas, Dave 'Boy' Green, Terry Downes, Bruce Wells and Vic Andreetti sat among fellow guests honouring the boxing champion.

The function was limited to 500 guests, but the twelve-year-old boy who had waited for Ali outside later received a small personal gift from the champion: a limited edition of a specially minted coin of the boxer inserted into a blue display card detailing his fights.

Guests were entertained by two bands and a cabaret, and later, Cllr Donald Gilbert marvelled at the determination shown by Johnny Walker,

Jimmy Stanley and Larry Shinwell, in their mission to bring the Greatest to Tyneside. It was this determination that resulted in everyone being able to receive the unique opportunity to personally meet the champion boxer, said the councillor.

Ali was then joined on stage by Johnny Walker and Ali recalled the tale of how Geordie Johnny had travelled all the way to America, armed only with hope and a dream. He said,

> 'My lawyers told Walker that it would cost at least $100,000. My lawyers only know money, not affairs of the heart. Johnny told the lawyers that he and the boys' clubs had nothing and that he had come to us for money.'

After his speech, Ali held a question-and-answer session with fellow diners. Despite the late hour, he stayed on, meeting guests and signing autographs. All this was the same day as a tiring transatlantic flight from America, delays with internal connecting flights, travelling up from Teesside, meeting thousands of people and boxing a few rounds at West End boys' club. Ali was still keen to continue, but others in his party were finding it difficult to stay awake. When he eventually hit his pillow, back at the hotel, it was said that he had gone without sleep for over twenty-six hours.

Day Two (15 July)

This was the day the Queen of England and the king of boxing would be visiting various places in the region at the same time. The Queen would visit Newcastle, South Shields, Sunderland and Washington as part of her Silver Jubilee celebrations and Ali would carry out his day's engagements in Newcastle, but unfortunately they wouldn't meet.

That morning at the Holiday Inn hotel, Muhammad was dressed in a brown pinstriped suit, complete with waistcoat, complaining of Newcastle's rather cold summer climate.

Their first stop was a visit to the Pendower Handicapped School to present a cheque from the previous night's Variety Club function. Ali's wife wouldn't accompany him, as she planned to do some shopping in Newcastle City Centre. Carol Maughan, employed as an executive secretary for Mill Garages and the only female chauffeur for the Ali motorcade, was assigned to be the driver for Mrs Ali. While Veronica and some of the Porsche family were driven to Newcastle in a small fleet of Mercedes, Ali and members of his team boarded the hired

luxury coach en route to Pendower School and then on to Grainger Park boys' club.

This would be a day that both pupils and staff of the children's handicapped school would never forget. The pupils were informed that not only would Muhammad Ali be coming to see them in the morning, but they would all be taken later to see the Queen of England during her stop off in Newcastle.

When the bus carrying Ali came to a stop outside of the school, the children lined up to welcome Ali. 'If you are happy and you know it, clap your hands,' sang the youngsters as Ali entered the school and was ushered through into the main hall. An emotional champion listened to the children's welcoming applause and, after being introduced, handed over a cheque to the school's staff from the Variety Club charity dinner.

Muhammad stayed with the children for over an hour, trying to give each child his individual attention. The champion presented seven-year-old Angela Davies with a standing frame, which had been made by local engineering apprentices. Another pupil, Stuart Evens, from Dolphin Street, Benwell, read out a poem dedicated to the champion. The poem resulted in some playful fisticuffs, with the heavyweight champion falling to the floor, and declaring Stuart the new champion.

Being with children, especially those with disabilities, always touched Muhammad's heart, and emotion was clearly visible on the boxer's face, as a teary-eyed Ali was presented with a hoard of gifts, ranging from a Jubilee mug and a bottle of aftershave to a specially made cake with the words 'Pendower School welcomes Muhammad Ali July 15th 1977' iced on the top. The boxer dabbed on the aftershave and helped himself to a slice of cake for tasting.

Ali also received questions from the children for over thirty minutes, with one boy asking why he began boxing. Ali answered, saying that after his new bicycle was stolen when he was twelve years old, he wanted to learn to box so that he could 'whup' the person who stole his prized possession. When asked how long he would continue boxing, Ali said that he wanted no more than two fights, because he was 'getting old'. Moans and groans followed that one. It was clear that the children didn't want to see the last of the famous fighter on television. Afterwards, he lifted young Paul Gardner up in his arms, with the boy clenching his tiny fist and landing a mock punch on the king of boxing's nose. Ali was clearly touched by his time with the children, but he left them to go to their next engagement: meeting the Queen off the Royal Yacht *Brittania*.

Ali boarded the luxury coach to take him to his next appointment, this being a visit to Grainger Park boys' club, situated a couple of miles down

through the winding streets in Scotswood, Newcastle. On the coach, the champion caused quite a stir when he momentarily took the wheel of the stationary vehicle, a bus that wasn't too dissimilar to the one he used to own and drive around during the 1960s. He called his private Greyhound-style bus 'Big Red' and it had giant hand-painted words on the side, reading, 'The World's Most Colourful Fighter' and 'Liston Must Fall in Eight' on the side panels. During the 1970s and later through his life and career, Ali still preferred driving to flying, and he would regularly be seen on the US freeways at the wheel of various RV motor homes he owned.

The 'big white' bus the champion boarded outside of Pendower Handicapped School that day found him in a fun mood as he sat alongside Jimmy Stanley's young son en route to the boys' club. The bus left and made its way to Grainger Park, but on the way Ali took everyone by surprise again, asking the driver to suddenly stop the coach. As the bus came to a screeching halt, everyone was wondering what was wrong. Ali then climbed out of the coach and made his way over to an old woman sitting in a wheelchair on the roadside. He tenderly held her hand and talked to her for a while, before returning to the coach.

Grainger Park, which in 1977 was one year away from celebrating its Golden Jubilee fifty-year anniversary, had previous moved from rooms above the Vulgan pub on Scotswood Road. In 1977, the youth club was based next to Scotswood swimming pool on Armstrong Road, and in the club's long history it had never had a surprise like this one.

Ali's visit to the gym came about via a surprise telephone call to head boxing coach Norman Close from Jimmy Stanley. Both were taken aback by their conversation. Norman was surprised by Jimmy's offer and Jimmy found Norman's words difficult to comprehend when Norman informed him that a visit could only happen if he obtained special permission for pro boxer Ali to be allowed in the ring with any of his amateur boxers. The permission was granted, and the visit was on.

As the bus came to a stop outside the gym, all the young boxers inside were already lined up to be individually introduced. Press and cameramen from both local and national television were jockeying for position as Ali walked in with his pal Paddy Monaghan, photographer Howard Bingham and boxers Dave 'Boy' Green, Vic Andreetti and Terry Downes by his side.

Introductions came from head coach Norman Close and Ali playfully squared up to each boxer, joking as he went along. The champion moved along the line-up of boys and approached eighteen-year-old amateur boxer Les Close. Les was already gloved up and ready for action when Ali playfully threw a jab in Les's direction. Young Les instinctively replied with

four accurate stiff jabs to the midriff of a surprised Ali. As coach Norman Close tried to introduce Ali to the next boxer in line, the champion turned back and pointed in Les's direction and said, with a twist of humour in his eye, 'You're the one I want!' Ali moved further along the line of boxers, each with their own individual way of welcoming the famous fighter to the gym. I was one of the privileged lads standing there that day and my own welcome to the champion came by way of my version of an Ali impersonation in a corny welcome poem. Shaking and finding myself practically clinging onto the boxer's arm, I blurted out,

> Muhammad Ali I welcome you here to my town,
> You've come here with no furious frown,
> Plus your heavyweight boxing crown,
> Oh, great one, enjoy your stay,
> And we shall all enjoy this memorable day,
> God save the Queen and Allah save the king,
> For you are the king of all the rings.

My loud-mouthed impersonation caught Ali's attention for a few brief seconds, but when he turned and said that I sounded 'just like him', those few words would linger in my mind for a long while.

Later, the champion walked over to an erected boxing ring with kid boxers, senior pros, press, cameramen and friends following his every step. Norman Close assembled a selection of young boxers to spar with each other for several thirty-second rounds to showcase the local talent. As the action in the ring stepped up, Ali, standing ringside, appealed to no one in particular for some gloves because he wanted to box too!

During a break in the kids' fisticuffs, Ali grabbed his chance and climbed up onto the ring apron, where Reg Gutteridge introduced him along with a host of other champions who had accompanied Ali to the gym.

During the introductions, Ali's eyes were firmly fixed on the boy boxer who dared to throw punches at him in the introductory line-up. To everyone's surprise, Ali then threw out a challenge to Les, which was to dare to spar with him. It was a dare that the kid couldn't refuse and would never forget.

The world heavyweight champion stripped off his pinstriped jacket and waistcoat, but surprisingly left his neck tie intact, maybe just so he wouldn't completely lose his formal appearance, and slipped on a pair of pillow-sized 16 oz sparring gloves and went two minutes with the amateur boxer. Ali weighed approximately 16 stone, with Les topping the scales at no more than 9 stone 7 pounds, but the size difference didn't stop them slinging what

looked like, from the gym floor, stinging punches at each other. However, many of Ali's punches were thrown open-gloved and aimed specifically at Les's moving gloves. The punches kept coming both ways, with the champion's voice rattling off as quick as his punches, asking Les repeatedly why he wasn't intimidated or scared of him.

Some of the harder punches even prompted Reg Gutteridge to call out to 'take it easy', but both boxers continued throwing leather until Norman Close finally ended their sparring session. Afterwards, Les, from Newbiggin Hall in the West End of the City, said that his few treasured minutes with Ali was all in fun, but his surprise bout with the Greatest still hit the front pages of the local papers: 'Lucky Les Fights The Louisville Lip' was the headline of the evening's *Chronicle* newspaper.

After Ali's gym workout he was ushered to the waiting bus outside, where he was taken back to the hotel at Seaton Burn. There wouldn't be much time for rest, though, as a tight schedule meant they were all due to attend the official reception at Newcastle's Lord Mayor's Mansion House later that afternoon (the official start time was 5.30 p.m.).

The Mansion House, situated a couple of miles outside the city centre on Fernwood Road in Jesmond, was and still is the official residence of the Lord Mayor. Before the time of Ali's visit, Cllr Hugh White's civic term as Lord Mayor had ended and Cllr Tom Collins now had the privilege of the civic duties that went along with the title. City dignitaries turned up at the Mansion House that afternoon, along with many of the boxers from the Parade of Champions, including former British, Commonwealth and European champion and former Ali opponent Richard Dunn, who turned up looking dapper in an all-white suit.

Entertainer Frankie Vaughn had already arrived and was greeting people and posing for photographs as Ali's motorcade arrived one hour late for the planned 5.30 p.m. start. Lord Mayor Tom Collins and Lady Mayoress Margaret Collins, who had both only ten days earlier held a civic reception for all the Atlanta Friendship Force members, joined the official line-up, alongside Ali, his wife Veronica and Frankie Vaughn. Surprisingly, Ali stood minus his new shoes, as he said they were too tight to wear.

My employment with the city information and publicity department meant that I managed to obtain an invitation that afternoon too, and I felt more than honoured when Ali remembered me from the gym earlier that morning. When he spotted me, Ali smiled and recited his own famous, 'float like a butterfly, sting like a bee' poem as we both shook hands.

When it was Richard Dunn's turn to be formally introduced, he started to remove his posh-looking white jacket, as if to continue their 1976

fisticuffs – all in jest of course. However, it was Ali's eleven-month-old baby, Hana, who really stole the show and knocked everyone out at the reception. She was brought along with mom and pop for the night's festivities and looked every inch a champion's girl, dressed in a mini ball gown, playfully wandering around carrying a matching handbag.

Lord Mayor Tom Collins later read out a welcoming introduction to Muhammad, and then a written poem was relayed to him. Ali liked both speech and poem so much that he asked if he could keep them. The poem, written by the *Journal*'s Peter Mortimer, went as follows:

Howay The Champ

To Tyneside you come
With your glory clouds trailing:
You're the champion of the world,
Who nobody's tailing.
You came bouncing right back
When they said you were failing.

With your butterfly dance
And your sting like a bee
The Geordies say welcome
To Muhammad Ali.

Muhammad Ali, you're still on the throne
Ain't no other fighter
That's ever been known
With a pen and a fist
To match up to your own
From the earliest days
Right through to the latest,
When they talk of the ring
And they mention the Greatest
There are only two men
Who it ever could be
Cassius Clay, then Muhammad Ali!

By Peter Mortimer
(Reprinted by permission of
Peter Mortimer and Mirrorpix)

Jeremiah Shabazz was handed the documents for safekeeping, while Ali signed the 1977 civic visitors' book, writing, 'Muhammad Ali. Peace 1977. Service to others is the rent we pay for our stay here on earth.'

Ali had previously been informed that the organisers were having trouble selling the tickets for various events, so after signing the visitors' book, Ali made a speech that took many by surprise. He said that he wanted to repay the costs of some of the airline tickets to bring his party over to help ease the financial burden.

The gesture would help with some, but not all, of the avalanche of costs that had mounted up, but his offer received a tumultuous and very appreciative round of applause from everyone in the room.

As the formalities ended and everyone relaxed and chatted, Ali turned to Tom Collins and told him that a Lord Mayor's job wasn't for him, as he found it very tiring standing around formally meeting and greeting people all the time. Ali, with yesterday's events catching up with him, looked fatigued as he flopped onto a couch, yawning in the process. He was joined by his wife and the Lady Mayoress. Muhammad momentarily closed his eyes, taking any opportunity to recharge his batteries before the onslaught of activities planned for later that evening began.

The gala banquet was meant to start at 6.45 p.m. at the Mayfair ballroom, but the start time had well passed by the time Muhammad, his family and entourage were persuaded to go outside to the waiting cars. Ali, now holding Hana in his arms, then decided to take an evening stroll through the grounds of the Mansion House. No one could rush him, but organisers were anxious to get everyone in the cars as people were waiting at the expensive charity banquet down the road in the city centre. Eventually, gentle persuasion was found to be the remedy and the champion climbed into the back seat of the limo.

The Parade of Champions banquet was attended by British boxing stars Terry Spinks, Chris and Kevin Finnegan, Dave 'Boy' Green, Vernon Sollas, Terry Downes, Richard Dunn, Alan Rudkin, Vic Andreetti, Johnny Clayton and Albert Tillman. The glittering occasion became a night to remember, not least for Bill Brown, who entered and won the *Shields Gazette* newspaper competition and was awarded two £50 tickets. To win his prize, he answered ten questions posed by the *Gazette* on the career of the heavyweight champion. Bill Brown, then thirty-seven years old, treated his girlfriend Elsie Swanson to an unforgettable night.

Before the lavish meal was served, committee chairman Clive McKeag stood and formally welcomed Ali, paying tribute to both the world heavyweight champion and his home country, the United States of America.

Guests sat down to the meal, with a main course consisting of sirloin steak chasseur. Afterwards, Ali took the microphone and turned in a star performance. The champion was one of the best in the world for holding the attention of a crowd and that night in the Mayfair ballroom it was no different. Words of wisdom, humour and his views on everything from boxing to religion captivated everyone in the room.

Ali's speech was followed by the cabaret, which was headed by Frankie Vaughn, with the Johnny Wiltshire Orchestra providing the backing. Frankie was assisted on the night by Charlie Smithers and Billy Marsh.

Following the cabaret came an auction, where a personally signed portrait of Ali, which had been shot at Turner's photographers the previous day, was added to a white pair of boxing gloves, also signed by the star guest and both going for over £1,000 apiece.

A 2-foot by 1-foot canvas mounted photograph of baby Hana was presented to Ali's wife, Veronica, by studio manager Kenneth Pope, and a specially minted gold-plated coin commemorating Ali's achievements in the ring, like the one given by Ali to Ian Pleasant the previous night, was also auctioned off for a staggering £800.

Fans like me, who unfortunately couldn't afford the expensive gala tickets, took comfort in a specially rearranged television programme about Ali that replaced the advertised *Police Woman* episode. The documentary film *Muhammad Ali – Skill, Brains and Guts* showed glimpses of not only Ali the fighter inside the ring, but also unique footage of his hilarious antics and humour outside of it. This documentary followed another tribute by Tyne Tees television called *The North Greets its Queen* in reference to the Queen's visit to Tyneside earlier the same day.

After the banquet, the champion and his party were taken back to the hotel, where he and his wife got some well-earned rest. The next day would be the busiest of his four-day visit.

Ali in South Shields (16 July)

This was the day that Ali would visit Johnny Walker's home town of South Shields, a day most people thought impossible and one that Ali himself said that he would remember to his grave.

Dick Kirkup was in charge of this part of the visit, arranging the open-topped Queen's Jubilee bus for the champion's procession and also helping to co-ordinate 'Muhammad Ali Day' on South Tyneside.

On the morning of 16 July 1977, Ali's motorcade arrived on the south side of the Tyne Tunnel, where everyone was transferred onto the Jubilee

open-topped bus, with Muhammad standing on the top deck and the sunshine coming out as the procession began through the streets.

Earlier in the morning, boxing booth owner Ron Taylor was still doing last-minute preparations for his fairground show. Incredibly, he was still finding selling the modest £1 entrance tickets difficult. The whole town was aware that the world champion was going through Shields, but most still didn't believe that he would stop off at Ron's booth.

On the Jubilee bus, it seemed that anybody who was anybody was aboard for Ali's sunshine procession: television cameramen, reporters, photographers, boxers, Ali's friends, town officials and even North East singer Alan Price, who was in South Shields at the time for a musical based on the locally built warship HMS *Kelly*. Thousands lined their route, cheering as Muhammad went past holding a rose, proudly flanked by Jimmy Stanley and Johnny Walker.

The procession bus, with a huge photograph of the Queen's face attached to the façade, was escorted by police motorbike side riders as it made its way along York Avenue, then onto John Reid Road. As the bus moved along, one boy watching the procession was fifteen-year-old Kevin Cameron, from South Shields. He stood waving and shouting as Ali looked down, acknowledging the young admirer with a wave.

When Muhammad's weekend in Shields came to an end, Kevin would become the lucky prize winner of a pair of Ali's signed boxing gloves, by way of another *Shields Gazette* competition. Up for grabs were two pairs of gloves personally signed by the champion boxer, and Kevin won one set which, he claims, he still holds today.

People stood ten deep, some searching out any vantage point possible, even perching on rooftops and shinning up lamp posts, all in the hope of catching a glimpse of the champion passing by. 'Ali, Ali, Ali,' came the cry from the crowd as the bus slowly moved along, and it was no different when they approached Laygate, which was the centre of the Arab community and location of the mosque where the next day's wedding blessing was planned.

The adulation and love was clearly visible in the eyes of those in the Muslim community. However, whether they were Muslim or Christian, young or old, everyone celebrated the arrival of the Greatest in town. One sixty-seven-year-old spectator, Nora Smith, had travelled especially from Tynemouth on the other side of the Tyne to see the procession. She even commented that the Queen's visit to South Shields didn't match Ali's, as the Greatest had travelled all the way from America especially to see them, while the Queen was visiting everyone in the country.

As the procession moved through the streets, Ali looked down at the mass of people who had turned out to see him, saying,

'You know, all I can feel is love and affection coming up from all these beautiful people, young and old alike. I have never been accepted in my own country the way I have here. It's something I will never forget. To think I have so many friends here in South Shields. I am going to tell them all in America.'

As the bus moved slowly forward, the sound of loose change dropping into buckets could be heard as many who lined the streets donated spare coins to the boys' club members, who carried the cash containers alongside the procession. When the Jubilee bus reached the town centre, the Heritage Hall New Orleans style jazz band joined them and the carnival atmosphere really started heating up. Crowds flocked and followed Ali along the appropriately named King Street and then onto Ocean Road. The boxer, looking like the Pied Piper of South Shields, led the procession and the excited townsfolk all the way down to the seafront amusement park, where Ron Taylor was awaiting him.

When the bus finally came to a stop, thousands had crammed into the showground, and Ali removed his jacket and walked off the bus into a crush of people, almost disappearing into a sea of police helmets, while he was squeezed towards the location of Ron's booth.

Ron later recalled that day, saying,

'They had a real job trying to get Ali up onto the stage of my booth. There were just so many people. It was really amazing because I only originally sold a handful of tickets for his appearance at that point, because of the overall disbelief of his visit.

'In fact, weeks later one man came up to me and said that his appearance almost caused a divorce in his house. I asked how come? The man told me that his wife was a great fan of Muhammad Ali and wanted to know why he did not get a ticket for my booth. I told him that I had offered him a ticket weeks previously, but he just didn't believe me.

'Anyway, they eventually got Ali up onto the outside stage and I introduced the champion to the thousands crowded there. Of course they all wanted a ticket to get into my show now. Ali took the microphone and said a few words. However, I could see that some of the organisers wanted to get him into the ring because I was only

granted ten minutes of his time, so I already had two cruiserweights gloved up. When Ali saw them he shouted to everyone that he wanted to take both of them on. The crowd was cheering as Ali squared up to the two boxers and then took the microphone and announced to everyone that my boxing booth was a marvellous thing for young people. The proposed ten-minute appearance turned into twenty. I then presented the charity organisers with a cheque.

'When it was time for him to leave, the police had their work cut out attempting to control the crowds. Afterwards, Johnny Walker came up and handed me an envelope. He said that this was a small gift for the appreciation of me giving the money for charity. In the envelope was an invitation for me and my wife Lily to attend Ali's marriage blessing and reception arranged for following day. I was shocked and pleased; this was something that I always treasured and remembered.'

(Interview with Ron Taylor, 2005)

Ali was then led through the amusement park, where he was welcomed by Jack Powell, who was on the syndicate of showmen. Jack handed over another much needed £250 cheque for the charity.

When Ali returned to the waiting bus, the procession continued along the seafront to Gypsies Green Stadium. The story was the same here: massive crowds surging forward, straining police resources as people crowded into the open-air sports facility. Muhammad stood stunned, almost looking like he was in a trance, as it appeared the whole town had crammed into the stadium to see him. Thousands crowded round as he was almost carried up the steps of an ad hoc platform by a swarm of fans and well-wishers. It was here that he was formally introduced to South Tyneside by Lord Mayor Sep Robinson and presented with a personalised illuminated scroll of honour.

As Ali stood before the massive crowd, there was an unusual challenge awaiting him. It would be a fifteen-round contest, which would have sounded somewhat familiar to the boxing champ, but the challenge on Muhammad Ali Day wouldn't be slinging punches, but feathered darts. The world heavyweight champion would face the world darts exhibition champion, Alan Evans, in a special championship contest.

The rules of the game were simple, in that it was over ten minutes, with each man going round the board hitting numbers 1 to 15, ending with a few shots at the bullseye. Evans could only score a point by hitting a treble on each number, while Ali could strike anywhere within each number to score his point.

Apart from the larger aiming target, there would be no additional help for Ali as the match would be refereed by the then general secretary of Durham County Darts Organisation, Sid Dowson. The game was over quickly and it was Alan Evans and the watching crowd that were stunned into silence as Ali won the game 11 points to 3. The boxer showed he was in fine form when he surprisingly stuck three darts in a row in the bullseye, beating the darts player at his own game.

Even Ali was puzzled at the ease of his win, but still declared himself the new world darts champion. Ali lifted his arms in the same victory salute he used against Sonny Liston and George Foreman, only this time knocking his opponent out was all in fun. The Welsh darts champion wasn't one for making excuses, but blamed the wind coming in off the North Sea, which swept through the open-air sports stadium, for his darts not staying intact in the board.

Ali's purse for the bout was £250, all of which went to the charity and was donated by sponsor Mr Tony Pritchard of Wilkinson the Jeweller in Frederick Street, South Shields.

For those watching who thought Ali was allowed to win, he was known to be pretty lucky when it came to instances like that. There was more than a good chance that he had never thrown a dart before in his life, yet he scored three bullseyes on the trot. A similar thing happened years earlier, when Muhammad was meeting fans on a basketball court. He was standing centre court, shaking hands and signing autographs, when someone handed him a basketball. Ali threw the ball in the direction of the net. You can imagine the look on people's faces when the ball actually went through the hoop!

Back in Shields, the champion rode round the stadium atop the Jubilee bus in a lap of honour and the sound of thousands of cheering Geordies caused Ali to call the day one that he would remember for the rest of his life.

Eighteen-year-old Billy Laidler, who stood and watched the procession go by, said something the whole town agreed with: that it would be a long while before South Shields would ever experience anything like this again.

Later, a civic reception and banquet was held in honour of the champion boxer at the town hall, and 260 specially invited guests sat down to a lavish meal. This took on an international flavour, as the American boxer was joined by visitors from twinned French and German towns.

Town Hall employee Peter Gillanders also found there was a special treat for his young daughter, who came along that day. She presented Ali with a special poem, written by her mother, which was also printed in the official Gypsies Green Carnival programme.

The poem went as follows:

He's coming, He's coming
Now who can that be
We know he is the greatest
MUHAMMAD ALI

South Tyneside a long time
Has waited to see
The biggest, the strongest
MUHAMMAD ALI

He floats like a butterfly
Stings like a bee
Our dearest, Our fearless
MUHAMMAD ALI

The children are speechless
The adults aglee
He's here as he promised
MUHAMMAD ALI

South Tyneside's a flutter
The moment is here
He stands like a God does
MUHAMMAD ALI

Gypsies Green Carnival
For all to see
We hope it will please you
MUHAMMAD ALI

There's sport and there's music
Displays and then tea
A really good day eh!
MUHAMMAD ALI

In aid of the boys' clubs
And our Queen's Jubilee
What more could we ask for
MUHAMMAD ALI

So look all you people
This programme's the key
For entrance to see him
MUHAMMAD ALI

We thank you dear Ali
We thank you truly
We know you are the greatest
MUHAMMAD ALI!

(Reprinted by permission of
Dorothy and Peter Gillanders)

Afterwards, Ali was joined by his friend Paddy Monaghan and rushed by car back to the north side of the River Tyne, to Newcastle city centre, where he had to arrive well in time for the planned 3 p.m. start of the live television talk-in at the Eldon Square Recreation Centre. The show would be hosted by ITV boxing commentator Reg Gutteridge and would be broadcast on the Saturday afternoon *World of Sport* programme.

It was the same in Newcastle when Ali was spotted. Mobs of adoring fans cheered as he arrived in the new shopping and sports complex, with the result of him being almost crushed as he was bundled up the escalator by a small army of people. On the top floor, Muhammad was escorted along a corridor into a small private reception room above the auditorium.

That day, I had already arrived armed with a City Council press pass and squeezed myself into the small reception room. Inside, there were only a handful of people present, including Ali, a few former champion boxers, Ali's close aids, a couple from the organisation committee and those with influence, such as big-time London promoter Jarvis Astaire.

John Gibson, the sports reporter from the *Chronicle* newspaper, was also in the room that day waiting to carry out an interview, and positioned himself near to where Ali was sitting. To the surprise of all of us, before the first question left John's lips, Ali jumped up off his chair and went to an adjoining room to be physically sick! The morning's extraordinary events, followed by a feast in South Shields town hall, had caught up with him and taken their toll. However, when he returned Ali carried out the interview with John, praising the Geordies and saying he felt like a king on Tyneside.

Years later, the sports journalist would admit that he had only ever asked for one person's autograph since his boyhood days. This was despite him eventually travelling the globe and meeting most of the biggest sports

stars of his time. It happened on that afternoon when Ali duly obliged him by signing a copy of his autobiography, *The Greatest*.

I sidled up to my boyhood hero, who I found chewing on a toothpick, and he obliged my nervous request for an autograph. He took a pen and scrawled his signature alongside the names of Terry Downes and Kevin Finnegan. Richard Dunn then came and sat alongside his former ring opponent and it was here, at this late hour, that Dunn agreed to take part in a few rounds of sparring with the champion later that night. Richard requested that Ali not throw any body punches, though, as he was still carrying eight stitches in his abdomen from a surgical operation only days earlier.

I was standing next to Richard that day and recall him hinting to his former famous opponent the possibility of retirement, but Muhammad gave him a few words of encouragement and told Dunn not to quit yet as he was a fine boxer and had many more fights down the 'path of pugilism'.

Richard would fight on, but for only one more professional fight, this being three months after leaving Tyneside, on 10 September 1977, against the world-rated South African Kallie Knoetze at Ellis Park Stadium in Johannesburg. Unfortunately, Richard would lose his last paid encounter by a fifth-round knockout and he would permanently retire afterwards.

Ali brought a ripple of laughter from the room when co-sponsor Jimmy Stanley just happened to walk in. Ali turned to no one in particular and shouted out 'hey, here's the President, Jimmy Carter', as he thought Jimmy the scrap-dealing businessman resembled the more famous Jimmy, who resided in the White House in Washington DC. It seemed everyone wanted to get their own personal two minutes with Ali before he left for the live broadcast, including Jarvis Astaire, who aired his views on the newly released film *The Greatest* to the champion.

Downstairs in the main hall, 900 people, including personalities from the world of sport and entertainment, were already seated. The 3 p.m. start time was fast approaching, and Ali was escorted from the room to a small area downstairs behind the stage where he waited for Reg Gutteridge's formal introduction.

Johnny Wakelin's 1975 hit song 'Muhammad Ali – Black Superman' boomed out through the speaker system and echoed throughout the hall as the champion walked out to a thunderous reception from the Geordies. Reg introduced the boxer as a man who transcended sport and who had the most instantly recognised face in the world. The talk-in (some of which was not broadcast) lasted ninety minutes.

Newcastle City Councillor Arthur Stabler was the first person in the audience to receive an opportunity to speak to the champion. He

welcomed Ali to Newcastle and was keen to know what his impression was of Newcastle upon Tyne and the people who lived there.

Ali said,

'The peace. The policemen here (Newcastle) do not wear guns like they do back home. There is no real violence. Last week in Chicago, twelve of my people, black people, died, and the week before it was twenty-four – all violent deaths. You practice what people in my country preach.'

(Copyright Mirrorpix)

Muhammad paid homage to the locals, telling everyone that his welcome in the North East was one of the greatest he had ever received anywhere in the world and the people here made him feel like a king.

During the talk, Ali playfully pointed to Richard Dunn, who was sitting with his ever-supportive wife Janet in the audience, informing everyone that he was going to box that night and Dunn was going to be one of his opponents.

Muhammad also spoke about his next real ring opponent, Ernie Shavers. He said that some people thought his reflexes were on the wane and it was possible that he could lose, but Ali assured everyone that defeat for him was highly improbable.

Fifteen-year-old local amateur boxer Dominic McQuiggin took his opportunity and wanted to know if the champion could give him some privy information about his upcoming bout, by way of predicting the round in which his September opponent would fall.

Ali told Dominic, and the millions watching on television, that the days of predicting the exact round that his opponents would crumble were over and the only forecast he could make for the Shavers bout was that he would make sure he turned up on the night.

The somewhat informal chat remained on boxing, when Ali commented on his third fight against Ken Norton in New York in 1976. This fight was judged extremely close and many thought Ali lost the decision and therefore should no longer be world champion.

Ali put the closeness of the fight result down to differing boxing styles. He explained the importance of 'styles' in boxing and how they can be the factor in explaining the difference between having a hard fight and an easy one. Ali said Norton's style of boxing would always result in a close one for him, while Frazier's style meant he was easier to hit. Frazier's style was similar to that of Rocky Marciano, but surprisingly he still said that

the 'Rock', along with past champion Jack Johnson, would give him his toughest fights. However, he said, the best fight in his own career was the third one against 'Smokin' Joe Frazier two years before in Manila.

Muhammad received questions from fight manager Andy Smith and former champions Terry Downes, Dave Green, and Bobby Neil, as well as former amateur champion Bruce Wells. Dave Green, who only weeks before had bravely fought unsuccessfully for the world title against Carlos Palomino in London's Empire Pool, Wembley, on 14 June, said that he was staggered by the tumultuous reception that Ali was receiving from the people of Tyneside. The champion said,

> 'It's the first time anywhere in the world that old people with walking sticks and wheelchairs have stopped to wave or shake me by the hand. That makes me feel great. To think that I came from America, yet mean something to ordinary folk in this part of the world'.

(Copyright Mirrorpix)

Bruce Wells, former light middleweight amateur boxing champion, who had a ring record of 385 wins and only three losses, was handed a microphone. His question wasn't about the champion's career or about what he thought of the hospitality of the Geordie folk, but if he could take part in the Parade of Champions exhibition boxing planned for later that evening. He asked Ali directly if he could go a couple of minutes of ring time with him. Muhammad, ever accommodating, said that it was already planned for him to box with various opponents, but if he wasn't too tired after that, he could go a round.

Johnny Walker was eventually handed a microphone and he took the opportunity to publicly thank his two sponsors, Jimmy Stanley and Larry Shinwell, for paying him to travel to America and to accomplish his personal dream. Earlier, Ali had only agreed to take part in the boxing programme if one of his opponents was Johnny Walker. That afternoon, it didn't take long before the two started 'hamming it up' before their evening exhibition bout. After some laughter and light teasing, Johnny informed the crowd to put their money on the Geordie.

One local woman stood up and asked Ali if he had any advice to pass on to her son, who was captivated and very keen on becoming a boxer just like Ali, but the champion came back with an answer that might have surprised many, deterring her from encouraging her son to become a professional fighter. The champion said that obtaining a good education and a job was

much more important. He didn't want to be used as an example for young kids to enter the fight game professionally, as he said his talents were unique and the chances of reaching the pinnacle of boxing as he had were very low.

When asked what he would do after his boxing career was finished, Ali said that he wanted to do all he could to help people throughout the world so that he could prepare himself to meet God, because he believed that everyone will eventually be judged.

The champion modestly said that his eventual departure from boxing could be compared to what would happen if supersonic Concorde (recently introduced in 1976) no longer flew and left the skies to ordinary jetliners. Reaffirming his pulling power, Ali informed everyone that no one could attract people worldwide like he did, as almost half the population of the globe tuned into his fights by satellite or were aware of the result of his bouts.

Inquisitive about why they called people from this particular part of England 'Geordies', Ali received his one-on-one lesson on 'how to be a Geordie' from a young boy sitting in the audience. The cloth-capped kid, perhaps only missing a whippet by his side for good effect, stood up and explained in his finest regional dialect that you had to be born within a certain proximity to the famous River Tyne to be called a 'real Geordie'.

Poetry followed the lesson, with the champion reciting some of his 'greatest'. One of these was 'The Legend of Muhammad Ali', which explains in both rhyme and comedy some of his past wins and how no one should ever doubt any of his fighting predictions.

A serious moment followed the poetry, when Ali said it was the love, recognition and strength gained by people he met around the world that helped him train harder for fights and that he always needed people around him. One such person who he liked having around was even invited up to the podium. Stepping up was his loyal supporter and friend Paddy Monaghan. Paddy sat with them and Ali told the story of how Paddy became his number one man in England. Paddy, casually dressed in denim jeans and jacket, listened to Muhammad tell everyone how it was him that coined the title 'People's Champion' and how Paddy would walk around town with banners proclaiming 'Ali is our champ' when he had his heavyweight title stripped from him in 1967.

When asked what he thought of Muhammad, Paddy replied in the form of a rhymed poem, saying that all heavyweight boxing champions have their time at the top, but all must eventually give way to Father Time. However, with Muhammad, it was different, as he would be forever known and remembered as the 'People's Champion', as he had touched the hearts and minds of people from every culture around the world.

Ali never forgot Paddy, who was welcomed over the years by the champion as of one his own family. The world-famous fighter had mixed with kings, queens and heads of state and had tasted fame at the highest level. It would have been easy for him to forget the everyday guy, but Paddy, sitting alongside him, was living proof that the Greatest never forgot his fans and those who supported him.

Ali also talked religion, ranging from the dietary rules of the Muslim religion to airing his views on all different religions and faiths throughout the world. He used the metaphor of different faiths as different rivers and streams, meaning that they all have different names, but they all contain the same message. The message Ali passed on was that all people could be good, if they practiced what their different religions preached.

The 'Ali meets the Geordies' show came to a close, with the Geordies being left with something to ponder when the boxer talked about how only a small percentage of a person's life is productive – as much time is spent doing unproductive things and that's why he was using his productive time on earth to help people and society.

I sat alongside 900 others, spellbound by Ali's interactive chat, but as quick as he arrived, he was gone. It was a quick drive back to the hotel in Seaton Burn. Again, though, there wouldn't be much time for rest, as the evening's exhibition bouts were only a few hours away.

That night at the Washington Sports Centre, fans stood in the early evening light waiting to welcome both Ali and Veronica. It was great news for everyone that he had changed his mind about not boxing while here, but a pity that the place for his once-in-a-lifetime Tyneside exhibition bouts hadn't been in the vast outdoor St James' Park stadium in Newcastle city centre.

Right up to Ali's arrival on Tyneside, his appearance on this night was promoted as just leading out a line of fellow champions and ex-champions. It had been too late to change the advertised billing or to reprint the official programme, which read 'The Parade of Champions – Led by Muhammad Ali'. Ali was now partaking in the boxing activities, but many in the region didn't get the news, so believed he was only going to be part of the introductory line-up and would sit ringside for the show. This could have been the reason for not all the tickets in the 3,000-capacity hall being sold.

On the night, local boxer 'Giant' George Scott was still on the shortlist to go one round with the champion, but was unfortunately deterred at the last moment because of his still reigning amateur boxer status. It was felt that swapping punches with top pro Ali might have some kind of detrimental effect on his imminent application for a professional boxer's

licence. So sadly, 'Giant Geordie' George sat on the sidelines and missed a fabulous opportunity to end his amateur career and start a professional one with a prestigious ring appearance with the Greatest.

Also, as the champion arrived in Newcastle adamant that he wasn't going to box, he didn't pack any ring clothing on his journey from the States, so a last-minute appeal had gone out to some of the bigger boys in the area for help. George Scott's non-appearance meant Ali had some well-fitting ring boots to wear on the night. George loaned him the same size 13 ring boots he wore in the ABA finals earlier in the year. The crimson shorts Ali pulled on came from the recent pro starter and already agreed spar mate to the champion, heavy Reg Long from Perterlee. The sparring mitts that all the boxers wore were supplied and paid for by the chairman of the South Shields Mosque Islamic Trust, Sayyad G. H. Shah, and his son Glen Zumir Shah.

Ali also borrowed a purple and yellow robe to sling over his shoulders as he left the dressing room. It would have been more apt, though, had he brought along, from the US, Elvis Presley's 1973 gift of the jewel-encrusted boxing robe. The words 'People's Choice' were emblazoned on the back of that gown, and those words perhaps best described Ali's time on Tyneside.

I was one fan among 1,500 others, paying a fiver for the chance to see the boxer in action, but prior to his anticipated ring appearance, there was a showcase of both local and national professional boxing talent.

First up was an exhibition bout by local featherweight boxer Alan Robertson, who only had his first pro fight during the organisation of the Parade of Champions event in May 1977, but would eventually go on in his career to hold a prestigious second-round stoppage win over the talented and future two-time world title challenger Pat Cowdell. Memorably, he would also one day in the future take part in another prestigious night of exhibition boxing against the late, 'great' Welsh boxer Johnny Owen. The bout against Owen would ironically take place in the same location as the gala banquet, at the Mayfair ballroom, but tonight, his entertaining exhibition bout was against former Northern Area amateur featherweight champion and promising bantamweight pro slugger Jackie Dinning.

Next up was another exciting punch-up between Vic Andreetti and Johnny Clayton. Both exchanged some heavy hits, much to the delight of everyone present. Dave 'Boy' Green was next up, against 'Big Jim Ford' Green who was a popular champion and received a rowdy reception. During his professional boxing career, he fought never-to-be-forgotten battles against the likes of Sugar Ray Leonard (1980), John H. Stracey (1977) and Carlos Palomino (1977).

Former featherweight champion Bobby Neil acted as referee for Green's sparring bout, but the assembled crowd were getting restless as the penultimate session took place between Kevin Finnegan and Albert Tillman. Classical and gutsy boxer Finnegan would, during his career, face Marvin Hagler (1980), Alan Minter (1975, 1976 and 1977) and Tony Sibson (1979) in heroic fights, but at the Washington Sports Centre that night a more reserved Finnegan went through the motions displaying his remarkable boxing skills against fellow professional Tillman.

When the preliminaries were over, the lights dimmed, and the spotlight shone on one person, flanked by a police escort coming through a crush of people. The man causing all the chaos and the centre of attention was the one that everybody said wouldn't come and who had said he definitely wouldn't take part in any exhibition boxing while here, Muhammad Ali.

'Ali, Ali, Ali,' came the chant from the crowd, as he made his way into the ring. Former world middleweight champion Terry Downes, who during his career would also hold a prestigious win over Ali's own boyhood boxing hero, 'Sugar' Ray Robinson, was the assigned star referee.

As Ali warmed up in the corner, it wasn't difficult to see that he was still far from tip-top fighting shape, which was a touch concerning to fans as he would be facing dangerous Ernie Shavers not too long after leaving Tyneside. Ted Hooper, the same compère who announced back in 1975 that John Conteh was a no-show, found himself in the role again, this time introducing the Greatest of All Time:

'Ladies and gentlemen, will you please welcome, from America, the world heavyweight champion, Muhammad Ali.'

A roar went up from the crowd as the boxing started and everyone was treated to more of Ali the actor than Ali the fighter. The champion was in a playful mood and his mind was set on having some light-hearted fun.

First up was the man who loaned him his boxing shorts, heavyweight Reg Long. Reg, who had only turned professional at the beginning of the year (1977), but had still crammed eight paid bouts in that time, would forever remember his few minutes sharing a ring with the legendary champion. Ali clowned his way through the action, with both exchanging light jabs and lots of smiles. Years later, Reg would hold his one-off exchange of punches against Ali in such high esteem that he compared it to 'sparring with Jesus Christ'.

Next up was former amateur boxer Bruce Wells. This was the same Bruce Wells who took a chance on asking Ali during his Eldon Square talk-in if

he wouldn't mind obliging him a couple of minutes in the ring. Ali made the dream come true for the former ABA and European light middleweight champion. Bruce's nerve to ask a favour led him to find himself face-to-face with the undisputed heavyweight champion, in front of 1,500 fans.

Presumably permission was granted for this former amateur/pro session, even though the amateur authorities could hardly impose any sort of penalty on Bruce, as his amateur career lay in the past. Anyway, quite frankly, no one cared, as Ali's boxing night was all in fun and Bruce deservedly grabbed his chance.

During their session, Bruce pressed Ali hard and the champion was floored within the first minute with a light tap to the side of the head. Ali, still clowning, got up on exaggerated jelly legs, but fell to the canvas again from another light punch. 'Jubilant' Bruce went into a victory dance as Andy Smith and Terry Downes helped his 'weary' opponent onto a waiting corner stool.

As Bruce climbed out of the ring, he could hardly contain his happiness – acting like he had just snatched the heavyweight crown from Ali's head by a one-round knockout, and jokingly shouting out that he could now be called the official world champion. Bruce couldn't claim Ali's title, but the photograph of him standing over the king of boxing must have been a highly cherished one throughout his life.

Next up in the ring to face the champion was the man behind the whole 'Ali on Tyneside' idea, Johnny Walker. What a special moment this must have been for him, as it was only a few months ago that the mere mention of the champion coming to Newcastle was talked about as an 'impossible dream'. But now the impossible was standing right in front of him in a pair of 16 oz boxing mitts. He was face-to-face with the world heavyweight champion, in a boxing ring in his home town. When the bell rang, they continued the play fighting that they had begun at the champion's personal boxing ring back in the Michegan countryside. The fisticuffs would now conclude in the unlikely setting of the Washington Sports Centre.

Both Ali and Johnny played up to the crowd and it wasn't long before both men found themselves on the canvas. The boxing, talking and clowning continued until they both ended up in a friendly embrace.

It was Richard Dunn who faced the world champion for the final two rounds of the night. After Dunn's defeat to Ali in Munich, 1976, Richard would never have believed it possible to ever face him again in a boxing ring, but here he was, one Saturday night in, of all places, the Washington Sports Centre. Ali went through his routines, including dancing on his toes and showing off the 'rope-a-dope' technique he made famous against Foreman in 1974. He was careful not to aim punches at the stitched-up midriff of Richard, but still

went six minutes, which incidentally was only eight minutes and forty-five seconds less than their real million-dollar encounter the previous year, which had ended in two minutes and forty-five seconds of the fifth round.

Richard Dunn would cement himself as part of Ali's legend, not only as his fifty-fourth ring opponent and last British boxer to face him, but also for being the last opponent he ever knocked out or knocked down in his professional career. Richard made a brave stand for five rounds in his world title bid, but unfortunately he faced an in-shape Ali who was looking to improve on his last disappointing performance against Jimmy Young.

After their paid encounter in Munich, the gloves that the two boxers wore that night would take different paths. Many years later, Richard told me that he still kept his prized mitts as a special memento from his first, and only, but well-deserved world title challenge. Recently, he told me that he had turned down an offer of tens of thousands of pounds to part with them, but is determined to hand them down to one of his twelve grandchildren (at the time of writing). The price can only increase over time, especially with Ali's personal signature etched on them, as Richard brought his championship mitts to Newcastle for the champion's specially penned touch.

The gloves Ali wore in their 1976 encounter were donated towards a fund in aid of former British and European light heavyweight champion and Parade of Champions invitee Chris Finnegan, who was unfortunately forced into retirement after surgery for a detached retina in 1975.

After the Dunn *v.* Ali exhibition bout ended, fans surged towards the ring, where the champion took a microphone and spoke of his appreciation for everyone turning up. Soon completely engulfed by people, Muhammad left the ring and pointed up to the balcony, saying that his new bride had come along to meet everyone too. To the delight of the attending fans, Veronica, with a little gentle persuasion, eventually came down and joined her husband within the hub of 1,500 North East supporters.

I was standing near to Ali and couldn't help notice one over-excited fan grabbing his hand hard and squeezing it so tightly that he winced and jerked his mitt away in pain. It was well known that he suffered from fragile hands throughout his career, so this was one Geordie that Ali didn't take an instant liking too. In a stern voice, he warned the man to be careful touching his hands as each one was worth over $5 million!

The toughest fight for the Greatest that night, though, came when he and his wife tried to leave the sports hall. People with hands outstretched, hoping for a handshake or touch, pressed forward as Mr and Mrs Ali were assisted by police to the dressing room, before later being driven back to the north side of the Tyne to their hotel.

Wedding Blessing (17 July)

Muhammad and Veronica, who married only weeks previously at the Beverly Hills Hotel in Hollywood, were now going to have their LA wedding blessed at the Al Azhar Mosque on Laygate Lane, South Shields, and the highly anticipated ceremony would be the culmination of Ali's visit.

The location of South Shields, right on the mouth of the River Tyne and facing out on the cold climes of the North Sea, means that it is not normally associated with balmy hot weather, but that July morning, the usual cool breeze from the ocean briefly stilled and the sun came bursting out, leaving the town feeling like a Mediterranean coastal resort. The glorious weather added to the occasion and the scene around the grounds and streets of the mosque was something to behold as thousands turned up for this special one-off event. Police estimated the crowd at 7,000, and even though temporary barriers had been erected to keep everyone back, it was never going to be enough.

Out of the thousands who turned up that day, only 300 were allowed into the mosque, but even this number was well past the capacity of the building's prayer room, as local council officials, boxers, friends, and families of those involved squeezed upstairs into the open-plan place of worship. The amount of people crammed in, combined with the unusual pulsating heat of the morning due to a reported error by the caretaker, who had accidentally left the heating on in the building that morning, left the temperature not far removed from inside a furnace, but no one wanted to miss the occasion and most carried on through the heat, awaiting the champion and his bride.

As the motorcade pulled up outside the mosque, Mr and Mrs Ali stepped out of the car to a fanatical reception. Muhammad was decked out in a cream suit and Veronica looked like a princess, dressed in a cream-and-white dress. They arrived for the 11.30 a.m. start and attempted to make their way along John Tighe's 50-foot by 4-foot green carpet, which had already been rolled out from the roadside up to the entrance of the mosque.

The Alis walked through a pressed-back wall of people, with everyone trying to push forward to get closer. As they made their way up to the entrance of the mosque, they passed a sea of faces. One in particular received a smile from Veronica, when she spotted chimneysweep Richard Drummond, complete with a blackened face as soot dust was still caked on his face from his last job.

One invited guest in the ceremony room was Johnny Walker's wife's relation, Jack Taylor, and wife Mary. Years later he recalled the scene inside the mosque that day back in 1977, saying,

'When we got to the mosque, you can just imagine what it was like – simply amazing. I remember entering the building and there were piles of shoes at the entrance. Even the police were standing in their stockinged feet.'

Johnny Walker watched proudly as his fifteen-year-old daughter, Wendy, was joined by the other attendants upstairs in a prayer room that was now bursting at the seams, even though some guests were unable to stay too long as the heat was almost unbearable. Boxer Richard Dunn found the temperature in the mosque that morning too much and joined some others in taking refuge outside. Inside, two women fainted, and baby Hana was returned to the cooler calm of their waiting car outside.

The Islamic ceremony itself was conducted in both Arabic and English by the Imam, Taleb Ahmed, and his words could be heard by the thousands gathered outside as external loudspeakers had been set up. During the ceremony, nine-year-old attendant Gamel Kaid, the daughter of the official at the mosque, also read out a section of the Koran.

When the short, ten-minute ceremony ended and Ali and his wife left the prayer room, Muhammad Kaid said the visit by Ali would go a very long way to help the continuing harmonious relationship between the Muslim community and all the other people in South Shields.

Afterwards, Ali said,

'I find everywhere I travel I have a home and have brothers in every city and country in the world. I will go back home and tell my people that we are accepted throughout the world. Only in the Islamic centres have I witnessed such real love. This will make me believe even more in the Islamic religion.'

One special gift for the newlyweds was from Mr Sayyad Shah, who presented them with a Koran, complete with English translations. Ali graciously accepted the gift, saying that he would keep it forever.

When the Alis left the building, they were faced with a small army of excited people, but one man in particular who managed to squeeze through the crush of thousands was fifty-six-year-old Bill Lodge, a caretaker at Boldon Lane Library. He handed over a gift presentation of a theatrical 'king's crown' on a velvet cushion, which Ali gratefully accepted, before reaching the waiting Mercedes.

Police resources were pushed to the limit, as they tried in vain to hold back an avalanche of thousands, but their cordons were insufficient and

their attempts to keep everyone back predictably failed. Barriers were knocked over as people broke through attempting to get closer to the vehicle carrying the champion and his new bride. Crowds swarmed the route of the departing motorcade, forcing the cars to a snail's pace. It seemed the whole town was trying to delay Ali's departure and police had to deploy all their crowd control skills just to get the line of Mercedes out onto the main road back to Newcastle. Chaffeur Carol Maughan even described the crowds as 'frightening', as people crushed up against the sides of the cars.

The motorcade left South Shields for the last time and sped through the Tyne Tunnel, back to the north side of the river. It was only a short drive from there to the venue of the reception. When the vehicles reached the entrance of Gosforth Park, Ali, his bride, daughter and members of Veronica's family, were transferred to a horse-drawn, open-topped carriage, which led them the final few hundred yards to the entrance of the Brandling, where another lavish banquet awaited them.

Invited guest Jack Taylor later said,

'When we all walked in, he [Ali] was standing in the foyer meeting people. He was such a handsome bloke, really big. I was 5 foot 8 inches and he towered above me, but he just put us at ease straight away.'

South Tyneside Lord Mayor Sep Robinson and his wife Pat were also guests and sat next to the champion and his wife on the top table. Sep later remarked,

'It is easy to get the wrong impression of Ali, a man who is always shouting his mouth off in fights. But in reality he is a very quiet man when he is away from advertising his fights. He has a genuine love of children and not just his own.'

After the festivities, another auction took place, and everything was sold, including the happy couple's wedding cake and even the roses Veronica had held during the blessing. Mrs Clay from Northumberland proved to be the 'Greatest' when it came to winning Ali auctions. Her bid won the wedding cake and also the signed portrait of the champion from the gala ball on Saturday night. Overall Mrs Clay spent £2,000 on the two items – a massive amount of money in those days. Gifts were also presented to the Alis – one a special tankard from Jim Merrington of Scottish & Newcastle Breweries.

Ron Taylor, who spoke to the champion after the reception ended, said he was asked by the boxer about his fairground booth. Ron said Ali liked

the concept of boxing booths and, according to Ron, asked him if he'd ever thought about bringing his show over to the States. Ron told me in our 2005 interview that he would have loved to do just that, but wasn't too keen on uprooting everything in the UK. It was here that the champion handed Ron one of the commemorative 'Ali coins', the same type that had just been auctioned off for hundreds of pounds on Friday night at the gala ball. Muhammad's gift was treasured by Ron Taylor for the rest of his life.

Later, an official Parade of Champions photo shoot also took place and Andy Smith invited Ron to join them in a line-up that included Muhammad Ali, Richard Dunn, Alan Rudkin, Andy Smith, Vernon Sollas, Terry Spinks, Kevin and Chris Finnegan, Albert Tillman, Bobby Neill, Andy Smith, Bruce Wells, Vic Andreetti, Johnny Clayton, Terry Downes and other prominent people in the sport.

Reporters received the opportunity to interview Ali afterwards. The champion again heaped praise on his Geordie hosts, saying now that he had met everyone and was so well received, Tyneside would be another place added in the world that he would recognise as having many fans, friends and supporters.

Perhaps initially inspired by coming to 'New'-castle, Veronica decided she would like to see a real ancient castle while in the region, and the bride's wish was granted after the Brandling reception ended. There were plenty to choose from, and although the castle in Newcastle was the obvious choice, the organisers opted instead for Alnwick Castle. The Ali party were escorted up north into Northumberland to the majestic home of the Duke and Duchess of Northumberland.

The Duke's family home would one day feature as the fictional school of Hogwarts in two of the Harry Potter movies, but on 17 July 1977 it was visited by someone who could claim to have performed his own brand of wizardry in the boxing ring. It was late in the afternoon when the Alis arrived at the pictureque countryside town of Alnwick. Unfortunately, the Duke and Duchess were not at home, but they spent around an hour touring the ancient fortress, which had once helped protect the northern English frontiers from Scottish warriors as far back as 1096.

So the king of boxing and the Duke of Northumberland missed each other, but surprisingly, two years later, the Duke and Duchess received a giant personally signed print photograph from Ali himself all the way from the new mansion home that he had purchased that year in Los Angeles, California. The photograph was also dated and the exact time of signing was added personally by the boxer, who would by then be a former three-time heavyweight champion (1.55 a.m. on 19 November 1979). The photograph

that arrived at the Duke's Northumberland castle home was surprisingly one that was taken and gifted to Ali by Newcastle-based photographers Turner's. The signed photograph would eventually find its way into the Castle's State Library and was part of a special 700-year anniversary display by the Percy family in 2011.

After the champion's ten-car cavalcade returned to Newcastle, he still found time to pay a visit to the Elswick Islamic Centre, situated in the west end of the city. The impromptu trip to Alnwick meant he arrived late, but on his arrival it was more hand-shaking and another enthusiastic welcome from over 1,000 people.

THE AFTERMATH

By Monday morning, the exhausting schedule over the past four days had finally caught up with Muhammad. It was said that the champion boxer was so fatigued on his final day that his 11.30 a.m. departure flight to London was postponed to the later time of 4 p.m. The good news was that this allowed additional and unexpected time in Tyneside.

The delay meant Veronica had some additional shopping time and Ali had the chance to fit in one previously postponed engagement. This was with Metro Radio to take part in Kevin Rowntree's popular afternoon chat show. With Ali 'live on air' and people aware that he was about to leave Tyneside and possibly never return, it didn't take long before the radio station switchboard became jammed. On the show, Ali turned in yet another hit performance, exchanging views with the Geordie callers.

Veronica's trip to Newcastle that Monday morning also caused quite a stir, as people walking along the city's busiest shopping road, Northumberland Street, first thought it was the champion boxer who was in town, as his motorcade of flash Mercedes was seen parked up. Inquisitive shoppers and passers-by quickly gathered and buses on the street came to a stop as crowds of people waited in anticipation, hoping to see Ali emerge from one of the many shops lining the city street. However, it was his wife, Veronica, who they saw leaving Fenwick's department store after buying a selection of gifts to take back to America.

After the radio talk-in, Ali returned to his hotel in preparation for departure. Dick Kirkup was with him in his hotel room in those final moments and asked the champion if he would ever one day return to the region. Ali answered, 'Yes, I will, and that's a promise.'

Ali's party were escorted by police from their hotel to Newcastle Airport, where reporters were waiting and hoping for a final headline-catching quote

from him on his departure, but the champion seemed too tired to exchange any more banter or make any more statements and remained tight-lipped. While on Tyneside, the champion had kept up a neck-breaking schedule of engagements and had been photographed doing everything from tucking into a giant 'Geordie Stottie' cake (a well-known local delicacy) to standing in his stockinged feet in the Lord Mayor's Mansion House.

Before leaving, though, Ali still had offers to make to the man that made possible his time in the region, Johnny Walker. He invited Johnny to the film premiere of *The Greatest* in London the following month and gave an open invitation for him and his family to come to his range in Berrien Springs.

It was a drizzly, wet final few hours for Ali in Newcastle, but people still came from afar to line up both outside the airport and along the walk-on roof of the terminal, to watch the champion board his flight. Ali's crowd-pulling power was in evidence for the final time in Newcastle when hordes of people stood and watched him run across the tarmac with baby Hana cradled in his arms. The boxer waved acknowledgement to the crowd, then boarded the waiting Trident jet. The plane taxied along the runway and took off through a blanket of rain-filled clouds, en route to London where the champion would spend a short time before returning to the States.

It had been a knockout trip, with most people stunned by just seeing him turn up. It might have been only a short few days' flying visit, but everyone who was involved in the organisation of his time here was left exhausted, although all proud that they had been part of a memorable occasion. Johnny Walker had every right to cherish this achievement for the rest of his life.

The committee started the long, drawn-out task of collecting the receipts from the various events, but it would be a long while before figures were officially released. Donations started coming in. By the end of July, South Shields alone had raised £1,507.11. Contributions such as £191.64 came from the Cigarette Components Sports and Social Club; £37.64 was raised from the South Shields and District Woman's Darts League, and Sid Downe, the man who refereed the Muhammad Ali *v.* Alan Evans darts match also sent Dick a further cheque of £20.

The most unusual money-raising idea came from John Tighe, the general manager of Wades Furnishings, who supplied the green 50-foot carpet for the champion and his bride to walk from their car to the mosque in South Shields. He offered to put the carpet up for auction to help aid the fund.

The ambitious £75,000 target set by the organisers could never be reached, but optimistic figures of £20,000 were talked about. Also, not included in the final amount would be all monies raised by the appearance of Muhammad at the Variety Club fundraiser on his first night at the Gosforth Park Hotel,

which was donated to local handicapped and underprivileged children. Also, half the amount raised at the South Shields carnival day would go to the Jubilee charity fund, rather than the regional boys' clubs.

In the months after leaving Newcastle, Ali's life was quick-paced to say the least. Among other places, he would find himself back in London at the beginning of August to attend the premiere of his new film, *The Greatest*, and also kick-start a multi-city European promotional tour.

On 29 September, the champion would be in New York, defending his title against Earnie Shavers at Madison Square Garden, then in October he attended a fundraiser for the Friendship Force in Atlanta, and in the same month travelled to Detroit, Michigan, for Muhammad Ali Day. He was also spotted ringside in Las Vegas on 5 November for Ken Norton's final title eliminator against Jimmy Young at Caesars Palace, and then flew off to Bogota, Colombia, on 14 November to box another fundraiser (in aid of a polio hospital for children) against Bernardo Marcardo.

On 2 December the champion turned up in Chicago to take part in another charity boxing exhibition, this time at Chicago's Auditorium Theatre against contender Scott Le Doux. The black-tie charity fundraiser was in aid of the Children's Institute for Developmental Disabilities and billed as 'A Night at the Theatre with Muhammad Ali'.

That same month, he also turned up at the Waldorf Astoria Hotel in Manhattan, New York, on 15 December 1977 for a press conference to announce a further title defence. His opponent had a mere seven fights and had turned pro only a few months earlier in January 1977 after winning a gold medal in the 1976 Montreal Olympics. His name was Leon Spinks.

Two weeks after the New York press announcement, Ali's 1977 came to a close with a celebration, when on 30 December, Veronica give birth to their second daughter, who they named Laila. Interestingly, Laila was born under the same star sign as her famous fighting father, this also being the same mystic sign as fellow legendary boxers Joe Frazier and George Foreman, and she would go on to show similar characteristics.

During Muhammad's boxing days, he would tell people that he would never want his son to box professionally. At the time, no one, not even the fantasy script writers from Hollywood itself, could have dreamt up a story that Muhammad Ali's youngest daughter would one day become a world champion boxer. In August 1999, Laila would make her professional debut, with her father sitting ringside watching her win by a first-round knockout against fellow female pro April Fowler; and in 2002, Laila would win a woman's super middleweight world title and become a huge celebrity and role model in America in her own right.

Back in the North East, on 2 June 1978, an initial payment of £10,000 was made at the same Holiday Inn hotel at Seaton Burn that had accommodated the champion's party during his 1977 stay. The presentation of the cheque was made by Geordie comedian Bobby Thompson to the NABC chairman, Mr Michael Cookson, along with Durham Association of Boys' Clubs (DABC) chairman Charles McFarlane. On the day, Mr Cookson said it was the biggest cheque North East boys' clubs had ever previously received.

That month, Muhammad and his wife would be found in Russia, where the now ex-champion was invited on a ten-day goodwill visit. Ali would meet Communist President Leonid Brezhnev in the Kremlin and, among other things, would take part in six tough exhibition rounds with a crop of top Russian amateur heavyweight boxers at the Soviet Army Club in Moscow.

After all the expenses of the events had been deducted, £11,214.58 (after expenses) was the final amount raised for the Northumberland and Durham Association of Boys' Clubs in the North East of England. Added to this was the £4,000 donation from the Variety Club and all the proceeds from their fundraiser night going to underprivileged and handicapped children. Also, there were the proceeds raised for the Jubilee fund on the carnival day in South Shields, together with other donations, meaning that overall, local charities benefited to the tune of a figure around £20,000.

As for the final separate amount raised for the boys' clubs, this was impressive, as the sum was effectively raised over only two days. The first day, all money raised was channelled into a different charity, and apart from an auction after the Brandling wedding reception at the Gosforth Park Hotel on Sunday, the champion's day was taken up with a wedding blessing, a wedding reception and visits to Alnwick Castle and the Elswick Islamic Centre.

However, in reality, it didn't really matter how much money was raised for the boys' clubs, as raising funds for them was the key and lever used to convince the champion to interrupt his busy schedule and travel halfway across the world to meet the folk of Tyneside. Some may disagree and argue that the main goal was to raise money, but there could have been many different ways to raise funds for boys' clubs. Muhammad wanted to fulfil Johnny's dream and help children at the same time, and this he did, even though he really didn't have the time to do it, but as he said, if one man went to all the trouble and travelled all those miles, just in the hope of meeting him, he deserved something in return.

Ali knew what it meant to those who met him and Johnny also knew Muhammad would enjoy meeting the strange-sounding Geordies, whose humour and warm hospitality wasn't that far removed from his own. The amount raised for the clubs came as an additional bonus.

What is worth mentioning, though, is that the final cash amount raised because of Ali's visit was still a vast sum of money back in 1977. In that year, an eighteen-year-old underground face worker in a local North East coal mine would expect to receive a weekly wage of around £53, rising to £74, with the average UK wage a smidgen under £68 per week, so there was an awful lot that could be done in 1977 with around £20,000.

Indeed, the £75,000 target might have been surpassed if the committee knew for certain and in advance that Ali would box an exhibition bout while on Tyneside. Then, the original plan of hiring St James' Park would have likely taken place, with the potential of selling tens of thousands of tickets. But the committee were informed prior to his arrival that he didn't want to participate in any boxing while in the region, so the Parade of Champions took place at the much smaller indoor Washington Sports Centre, with Ali only planned to lead out fellow boxers into the ring, without himself lacing on the gloves.

Although the NABC and DABC may disagree, it really wouldn't have mattered if only one penny was raised, as the champion's time on Tyneside was the result of one man's fairytale adventure to America. No one thought Johnny would achieve his ambition, but he did and Ali's Geordie times became etched in people's memories, not because regional boys' clubs received the highest donation that they had ever previously received, but because Muhammad said yes to a more than ambitious request by a local painter and decorator who had long possessed his very own special 'impossible dream'.

On leaving, Ali told Dick Kirkup that he not only wanted to return to the region, but that he promised to do so. As we all know he never returned, but it is this which makes Johnny's achievement all the more special.

Seven years after Ali left our city, my fan-ship and following of the Greatest led me all the way to his mansion home in Los Angeles. While there, I recalled his visit to my home city in 1977 and he well remembered his times there and some of the characters that he had met while there. Ali had me creased up laughing when he jokingly said that he wanted to return to 'New'castle before it became 'Old'castle, but in a more serious moment, he said that his ever-busy travelling schedule meant that it was always difficult to do so.

So Ali's busy agenda meant Johnny's achievement of 'getting his man' happened in a unique moment of time that was never repeated, and one that may not have even happened if 'Mission Impossible' had been attempted at a different time. Ali was known to be one of the most accessible of all athletes, but locating him wasn't always easy, as his schedule normally kept him on the move.

Of course, it also helped greatly that Johnny received the invaluable support of Ali's Chicago-based manager, Herbert Muhammad, and the *Chicago Daily News*, but it was even more fortunate, or plain lucky, that the champion was actually home at that time, albeit in his Michigan farm, rather than at his mansion residence in Chicago. In truth, he could have been anywhere in the world when Johnny flew off to the States, but to everyone's relief he was found only a two-hour drive away in the adjoining State of Illinois.

So the fortunate timing of Johnny's US adventure and the invaluable help he received while there helped lead the Greatest to his once-in-a-lifetime visit to Tyneside. This, combined with the arrival of the Queen, the President of the United States and the Friendship Force Ambassadors of Peace from Atlanta, Georgia, all combined to make 1977 one of the most memorable years in history for everyone in the region. The main thing to remember, though, is that Muhammad Ali's name wouldn't have been added to that list of special visitors if Johnny's request for a huge favour from the Greatest wasn't met with such kindness and generosity.

I am also sure that the champion's own feelings on his time in the region wouldn't have differed much from what he wrote in the Newcastle Lord Mayor's visitors' book on Friday 15 July 1977:

'Service to others is the rent we pay for our stay here on earth.'

Sadly, since the day Muhammad wrote those words, many of the main characters who worked so tirelessly to make the champion's visit possible, and many who added to his time here, have passed away.

Johnny Walker, the man with the 'impossible dream', very sadly died on 1 January 1999 after a long battle against cancer. Both sponsors of Johnny's US adventure, Jimmy Stanley and Larry Shinwell, have also passed on since those summer days in 1977. They are joined by Dick Kirkup, the *Shields Gazette* sports writer who played such a important role in the organisation, publicity and promotion of both 'Mission Impossible' and Muhammad Ali Day in South Shields, and singing star Frankie Vaughn, who performed for free at the gala ball at the Mayfair ballroom and supported the Parade of Champions charity event from its inception. The list also includes Ali's manager, Herbert Muhammad, who backed Johnny's grandiose idea in writing; Jeremiah Shabazz, who aided in the organisation of the visit from Chicago and was one of his travelling companions to Tyneside, and also fight manager Andy Smith, who gave some invaluable advice to Johnny while he was formulating a plan to make his long-held dream come true.

Even some of those who played bit parts in Ali's 'Toon Times' have now sadly passed. Ron Taylor, the king of the boxing booths, passed away only one year after I interviewed him at his caravan in Gloucester. Phil Fowler, who received the surprise news that the world heavyweight champion would visit his West End boxing gym on his first day on Tyneside, passed away and is still missed by his troupe of boxers. Bruce Wells, the former amateur boxing star whose own 'impossible dream' came true when Ali allowed him to go a sparring round with him, also died in 2009, aged seventy-six. Joining him are fellow Parade of Champions invitees Kevin Finnegan, former Olympic gold medal winners Chris Finnegan and Terry Spinks, Welsh world champion Howard Winstone and former British, Commonwealth and European bantamweight champion Alan Rudkin.

Reg Gutteridge, the knowledgeable and very likable ITV commentator, who interviewed Muhammad during his time in Newcastle and who had a long personal friendship with Muhammad, also died in 2009, aged eighty-four, after suffering a stroke.

Revd Wayne Smith, the founder of the international Friendship Force, who convinced the champion to surprise everyone by turning up at the farewell dinner at the Civic Centre, and who eventually invited Muhammad onto the advisory council of the Friendship Force, died on 16 June 2004, aged sixty-nine, at his home in Big Canoe, Georgia. He was also joined by former Lord Mayor Tom Collins, who formally welcomed the Ali contingent to Newcastle upon Tyne, and Alan Evans, the former world darts champion who faced Ali at Gypsies Green Stadium, who very sadly died at the early age of forty-nine in 1999.

They will all be greatly missed by their families and friends but, I am sure, despite the long lists of their other individual lifetime achievements, they would have carried those special memories of Ali's time on Tyneside with them for the rest of their lives.

In 1996, the chief bridesmaid for Muhammad and Veronica's South Shields blessing was married herself. This was Johnny Walker's daughter, Wendy. She married Alan King, a Nissan worker, at Whitburn Parish Church. A surprise telegram arrived on her big day. It read,

'To a wonderful girl. Wishing you every happiness for your future, from Muhammad Ali.'

Muhammad's 'Toon Times' are now stored in the memories of those old enough to remember the occasion. Of course, some younger people are unaware that *the* Muhammad Ali, who they read and hear about today,

actually turned up at all. When I talk to some younger people in Newcastle, many take some convincing that the man they watched on television being voted Sportsman of the Century was once driven in a bus along Armstrong Road en route to Grainger Park boys' club.

The ones who did meet him, though, will have captured their special moment in time forever as he touched the lives of those he met in a way that only he could. And, as time marches onward, the Greatest's acceptance of a Geordie painter and decorator's invitation only adds to his 'People's Champion' title, which still clings to him to this day. Muhammad's lawyers didn't get that $100,000 for him coming to Tyneside, but the champion's promise was repaid in something dollars could never buy: the love and appreciation of the people of Tyneside.

Now that surely was priceless.

ALI LEAVES NEWCASTLE FOR HIS LAST 'GREAT' FIGHT

One week after Ali left Newcastle, he finally signed a contract in New York to defend his title against Earnie Shavers. Many boxing experts were split on the chances of Shavers causing an upset, with some feeling Earnie would be Ali's most dangerous opponent since the Greatest KO'd George Foreman back in 1974. Shavers would be facing a champion who was, by then, three years older than when he had arguably his greatest win against Foreman. Three years can be an awfully long time in a fighter's life. Ali had won nine fights since bashing George, but some of those wins took a heavy toll on the thirty-five-year-old boxer.

One of those victories was his third 'thriller' against Joe Frazier. Prior to the fight, it was thought the bout in Manila would be a relatively straightforward one, as Joe had already lost a return bout to Ali in January 1974. However, the fight ended in a titanic struggle of epic proportions, with Muhammad calling the fourteen rounds 'the closest thing to death' in a heat-absorbing and punishing all-time great title fight in 1975. Previously that same year, both Ron Lyle and Chuck Wepner had given the champion a bruising extended night before he eventually overwhelmed them.

In 1976, Ken Norton and Jimmy Young had taken the champion to within a whisker of his title and Muhammad's Tokyo encounter with the heavyweight Japanese wrestler Antonio Inoki left him with damaged legs requiring medical treatment. For fifteen rounds, Ali received full-force kicks below the belt (legs) from the heavyweight mixed martial arts fighter.

Shavers was a different proposition to Ali's last ring opponent, Evangelista, as Earnie was a proven hard-punching contender and he believed he was catching the champion at the right time. However, a section of the world's press still felt this bout would be just another routine fun night for the champion, where he could end it any time he wanted.

The bout was signed for September, but Muhammad Ali's busy 1977 agenda meant that he was back to London at the beginning of August as part of a multi-city European tour to promote his film *The Greatest*, with the UK premiere set for The Empire, Leicester Square. Ali eventually returned to his Deer Lake Training Camp in Pennsylvania, to resume training for the bout, but there were constant distractions.

Ali attracted people like no other athlete, and the camp he used for his fight preparations was well known for visiting celebrities and hoards of fans. Michael Jackson and his brothers were one famous platoon that turned up. Another time, Elvis Presley secretly arrived (staying in one of the world champion's log cabins without any visiting fans knowing) and Tom Jones even went two rounds sparring with Ali in 1980.

Arriving back at camp on 15 August 1977 after a demanding European promotional tour for his film, it was no different. The following day, among others, artist Andy Warhol showed up snapping photo shots of Ali as part of a commission by US businessman and art collector Richard Weisman for Warhol to paint a selection of ten famous athletes. Ali was included alongside other athletes such as Pelé and O. J. Simpson, in the group of unique paintings called the 'Athlete Series'. A limited number of eight paintings of each athlete was produced, with one of the originals going to the subject.

Muhammad was paid a five-figure sum for allowing Warhol to take a few photographs that day. At the time, a completed painting was selling for around $25,000. This was certainly a great investment, when an original 40-inch by 40-inch silkscreen painting of the former world champion, signed by the artist and rumoured to be the one previously owned by the Ali family, later sold at a 2007 Christie's auction in New York for $9,225,000!

Andy Warhol's visit to camp was just another extraordinary day in the life of Muhammad Ali, but visiting celebrities and fans weren't the only distractions. Sometimes Ali would leave the rigours and regime of training and take off in his RV motor home or fly off to accept some out-of-state invitation. Many in the press made known their concerns, but trainer Angelo Dundee reassured everybody and was confident that his fighter would be in great shape in time for his bout with Shavers.

In many ways, it wasn't surprising that Ali wanted to take breaks during that period, as he had only been recently married, but people who were financially backing his 'September showdown' weren't seeing it that way. Madison Square Garden publicist John F. Condon complained about Ali's reportedly casual approach when it came to the training camp regime and the discipline expected during the build-up to a fight.

It was said that in one two-week period of training, Ali missed over half that time, taking part in alternative activities that did not involve lacing on the gloves. For example, in early September, he turned up at the White House in Washington DC for dinner with Jimmy Carter on 7 September 1977 to celebrate the signing of the Panama Canal treaty. This was barely three weeks before his championship bout.

Two attempts were made to get the champion to seriously buckle down and curtail his impromptu out-of-town engagements. These arrived at Deer Lake by way of a letter from John Condon and a doorstep visit from Floyd Patterson, who was then employed by the New York State Athletic Commission.

The influential duo strongly advised Ali to take more seriously the responsibilities of getting in top shape for the September bout, but all appeals seemed to fall on deaf ears as Ali brushed off their concerns. The champion had forever done things his way and said he didn't need anyone's advice or instructions on how to prepare for any of his fights.

However, concerns about Muhammad's upcoming bout were not only based on his reported lack of preparation or Earnie's reputation as one of the hardest-hitting heavyweights of all time. Reports leaked out from the champion's camp that he had not only been knocked down twice by spar mate Jimmy Ellis, but was witnessed to be using his right hand only sparsely during sparring, which fuelled rumours about possible damage to this mitt. As previously mentioned, even during the champion's time in Newcastle, he was seen to wince in pain when one overzealous spectator squeezed his right hand after he completed his sparring bouts at the Washington Sports Centre. These issues didn't bode well, but there were more.

Around this particular time, there was an ominous feel in the air, as other 'kings' of the sport and entertainment world, whose flame of stardom shone brightly during era of the Greatest, were beginning to fade and burn out. Pelé, Ali's equivalent on the football field, was set to call it a day and retire from playing professional soccer. His farewell took place on 1 October 1977 in the Giants Stadium in New Jersey, USA. Pelé played an exhibition game between New York Cosmos and Brazil's Santos, in front of 77,000 fans, playing the first half for the Cosmos and the second half for Santos. Ironically, Ali would attend the footballer's final hurrah as it was held only two days after the Shavers bout.

In July 1977, fellow boxing legend Carlos Monzon, who was born in the same year as Ali (1942) called it quits after eighty-seven wins and only three defeats. Monzon, who also shared the 1972 *Ring Magazine* Fighter of the Year award with Muhammad, closed the curtain on both

his championship reign and career after retaining his title against Rodrigo Valdez on 30 July 1977 in Monte Carlo.

In the entertainment world, they came no bigger than Elvis Presley, but the king of Rock 'n' Roll and Ali's friend sadly died in Memphis on 16 August 1977 and left a world in mourning. Muhammad, who was sometimes referred to as the 'Elvis of boxing', had already stated publicly that 1977 would be his last year in boxing, but some experts thought the champion was still dangerously outstaying his time in the fight game.

Ali, born with the ancient Roman name of Cassius Marcellus and winning an Olympic gold medal in, of all places, Rome, had a career that seemed to follow a pattern. Clay turned professional on 29 October 1960, won the title in 1964 and had his title stripped in 1967. This was matched by his first comeback fight on 26 October 1970, exactly ten years, almost to the day, from his first professional fight. He regained his title in 1974, exactly ten years after his first title win against Liston in 1964. Now it was 1977, exactly ten years since his first enforced lay-off in 1967 – so if the pattern continued, 1977 would definitely be his last year in boxing. A few boxing experts stuck their neck out and predicted Ali's demise against Shavers, and some journalists and fight fans just wanted to see how the current champion's 'granite jaw' would stand up to the 'rock fists' of Mister Earnie Shavers.

Prior to the bout, Ali was his normal, super-confident self, predicting that he would have an easy victory. He said that Shavers' bald head reminded him of a black acorn and proclaimed that, since he was fighting in the Garden (Madison Square Garden) in the autumn, a time when acorns fell off trees, then it must be right that Earnie – the 'acorn' – would fall in Madison Square Garden on 29 September.

It was thought that Shavers was an acceptable opponent by the Ali camp as he had always been victorious against the big punchers of the division, knocking out KO specialists like George Foreman, Sonny Liston, Cleveland Williams and Ron Lyle. All of these boxers had failed to reach the final bell when they came face-to-face with the man who called himself the Greatest and, despite Shavers' impressive record of fifty-two knockouts (twenty in the first round*) out of fifty-four wins from sixty bouts, he had lost two fights against opponents that Ali had previously stopped. The first was to Jerry Quarry in 1973, who beat Shavers in the very first round. Ali had stopped Quarry twice previously in 1970 and 1972. The second was

*BoxRecs suggests Shavers had nineteen first-round knockouts going into the Ali bout, while his biography suggests twenty.

Shavers' loss to Ron Lyle in 1975. Ron suffered a knockdown early, but recovered and stopped Earnie in the sixth round. Ron Lyle also fought Muhammad for the world title in 1975 and was stopped with a blistering multi-punch combination in the eleventh round. Shavers had suffered another stoppage loss early in his career against a man that Joe Frazier stopped inside the distance, this being Ron Stander in 1970.

In Earnie's favour, Ali's unorthodox jab-and-move style of boxing was suited to his very powerful right hand. Earnie had lost fights against people that the champion had handled relatively easily, but in boxing, as Muhammad himself said in his interview with Reg Gutteridge in Newcastle only months earlier, sometimes it came down to different styles determining the outcome or ease of bouts.

Most notably, Jerry Quarry and Ron Lyle, who both defeated Shavers, had nothing in common with Muhammad's style of boxing. They were expert, speedy and heavy fisted counter-punchers who ended up outslugging Shavers. Classic-styled boxers who jabbed and moved in a traditional, orthodox method of boxing – especially ones that moved in a clockwise direction – similar to Ali's style – were sometimes caught alarmingly short when facing Shavers, simply because there was always a chance of colliding with his powerful right mitt.

Ali's boxing style stemmed from the classic style, but added were his unique reflexes and natural flair and ability, which allowed him to take incredible risks in a boxing ring. Less talented fighters had a greater chance of being caught out by a heavy puncher like Shavers, but of most concern to the champion's fans was that his dancing movements and reflexes had naturally become slower over time.

Former opponents of Shavers – most notably, Jimmy Ellis, Jimmy Young and Henry Clark – who were all basically stand-up orthodox boxers and who had mildly similar box-and-move styles to Ali, had quickly tasted Earnie's power and were all destroyed inside three rounds (Shavers' return fight with Young in 1974 ended in a drawn contest, but his first fight with Young ended by TKO in three rounds in 1973 and his first contest with Henry Clark ended in a points win for Shavers, but a return fight six months later ended in a second-round KO in Earnie's favour).

Some boxing experts made comparisons between George Foreman and Shavers. True enough, both had knocked out or stopped the majority of their opponents, but unlike Shavers, up until 1977, Foreman's defeats were against slick boxers, Jimmy Young and Ali. Many behind the champion believed Earnie would eventually tire and wind up being stopped in the later rounds as Foreman had back in 1974.

Shavers did have fights where he tired in the later rounds, but the similarity to a young Foreman ended there. The Foreman of the 1970s fought most of his fights as though each round was the last one coming up, and sometimes it was, as he would come out blasting with wide, swinging, clubbing punches. Earnie was different, in that he was basically a boxer with an orthodox style, but possessed devastating power in his fists, especially in his right mitt. His favourite punch normally wasn't thrown in a predictable wide-swinging fashion like big George's, but straight from his shoulder, and Shavers' right hand had the tendency to arrive by surprise with sometimes devastating results, especially in the early rounds. The impact of Earnie's wallop could be more damaging if you were a boxer-mover who circled in a clockwise direction – the same direction of the firing range of Earnie's heavy right fist.

In the champion's favour, this would be Shavers' first attempt at a long-haul fifteen-round contest, while it was Ali's twenty-fifth attempt at the traditional championship distance (taking into account his scheduled fifteen-round non-title encounters with Jerry Quarry (1970), Oscar Bonevena (1970) and Mac Foster (1972).

However, one factor that couldn't be overlooked was Muhammad's mental attitude during this period of his career. He seemed to be going through the motions in his last fight against Evangelista and he had already announced his retirement after the Norton fight in the fall of 1976, but changed his mind. Going through the motions in a fight with someone who had knocked out almost everyone he faced could be thought of as more than a touch risky, but he had spent his ring career taking risks and he had come out on top most of the time.

The champion's reflexes in 1977 were not what they had been in 1964 or 1974, but they were still superior to all the other top heavies at the time (with the possible exception of Larry Holmes, who wouldn't win a world title until a year later in 1978). Ali had watched films of Shavers tasting defeat early, against Quarry and Lyle, and tiring late in some fights. One film in particular he watched was Shavers' bout with Roy 'Tiger' Williams, which took place the previous year in 1976. Although Earnie won in the last round by KO, he was seen to visibly tire and seemed completely spent going into the tenth and final round. Presumably, Ali believed Shavers was just another one of those opponents who he could handle with relative ease, as his track record proved he had been hugely successful against heavy handed boxers who had a tendency to tire late in a bout.

In Ali's first championship reign in the 1960s, his saying of 'hitting hard don't mean nothing if you can't find anything to hit' rang true. By

the mid-1970s, his opponents had been connecting more regularly, but even when punches reached his jaw, it was discovered that his slowing reflexes were matched with a granite-like chin.

Boxers who became heavyweight champions in Ali's professional boxing life from October 1960 to the time of the Shavers bout in September 1977 – i.e. Floyd Patterson, Sonny Liston, Ernie Terrell, Jimmy Ellis, Joe Frazier and George Foreman – had all been knocked out or stopped sometime in their respective careers up to that point. Up to 1977, Ali was the only champion among those mentioned who had never suffered a KO or stoppage loss, so it wasn't surprising that he was super-confident that he couldn't be knocked out and more confident that no one could outbox him over fifteen rounds.

Supreme self-belief was one of the champion's fighting trademarks, and this approaching bout was no different. He said the fight might end even quicker than people expected, possibly in a repeat of his 1965 two-minute destruction of Sonny Liston.

Ali's prediction of an early finish wasn't what US television giants NBC wanted, as they were the ones screening his fight live, coast-to-coast in the US. Advertisers were forking out small fortunes to promote their products and services while the fighters rested the one minute between rounds. The longer the fight went on, the more paid airtime they would receive. 'The Champ and Demolition Expert' was how NBC promoted the bout, and viewers would be given the unusual privilege of keeping up to date with the official scores on a round-by-round basis, as each judge – one being Eva Shane, who would be the first woman to judge a world heavyweight championship fight – would have their scores displayed on screen after each round.

Days before the championship bout, Madison Square Garden inducted Ali into the Hall of Fame, and on the day of the weigh-in, Richard Weisman, who commissioned Andy Warhol's 'Athlete Series' of artwork, turned up in Madison Square Garden and presented Muhammad with one of Warhol's finished works of the champion boxer.

When fight night arrived, movie star Sylvester 'Rocky' Stallone, who was taken by surprise by Ali at the academy awards ceremony earlier in the year, was one ringside spectator among 14,613 in attendance, and an estimated 70 million others watching on live US television, who witnessed an unforgettable and electrifying battle.

The champion left his dressing room to the sound of the theme music from the then recently released movie *Star Wars*. The film title was certainly appropriate in relation to what followed, as a 'star war' was what fans witnessed after the first bell sounded.

Early in the fight, Ali was seen absorbing some thunderous right hands, which seemed to rock him to his boots. The powerful punches winging the champion's way might have made many in the arena believe they were seeing his prediction of an early finish come true, although not as he had envisaged, but he gritted his teeth and showed the quality of a true champion, eventually fighting his way back in. In some rounds Muhammad was knocked and socked so hard that a couple of times he seemed to be out on his feet, but his fifteenth-round onslaught almost stopped Shavers reaching the final bell. The 'acorn' managed to hang on and not fall in the 'Garden', reaching the end of the bout, but only to see star Ali win the war and remain champion of the world by a unanimous points decision.

However, Ali's points win didn't reflect the story of what happened inside the ropes, and people saw for their own eyes the champion being rocked by tremendous punches on too many occasions.

In the champion's dressing room, where only the inner circle of Ali's aids and close friends were allowed, his father implored the boxer to retire. It took a fatigued champion more than one hour to leave the locker room to face the waiting press. When interviewed, Ali admitted that he was almost knocked out on a couple of occasions, but 'closed the show' like a real champion should and came back to win the fight.

Muhammad had nothing left to prove after this bout and this was a good time to get out, but the same could be said after the Foreman fight in 1974, after the third Frazier fight in 1975 and after the third Norton fight in 1976. However, he made the decision to fight on.

Putting aside his world title belt to gather dust can't have been an easy thing for Ali to do. Being the world heavyweight champion helped him become arguably the world's most recognised person and an extremely wealthy man. But the writing was on the wall after this super-bout and influential people started making a stand publicly about the champion prolonging his career. Ali's long-time personal doctor, Ferdie Pacheco, who had previously expressed his concerns about the boxer continuing in the fight game, finally checked out from working in his corner, publicly and privately pleading with him to depart from boxing.

Pacheco was joined by the promoters of the championship bout. Teddy Brenner, president for Madison Square Garden Boxing (MSGB), said that even though Muhammad Ali was a huge cash generator, he sincerely felt that he should retire now, and that he didn't want to see another Ali fight contract on his desk. History shows that the champion never fought in Madison Square Garden again. However, Ali's 'definite' last year in boxing

rolled on into another year, but he was defeated in his very next fight, on 15 February 1978, losing his world title to one-year 'professional-rookie' Leon Spinks.

As for Muhammad's career following a pattern, his title defence against Shavers in 1977 became his last-ever successful defence as champion (his last title defence in his first reign as champion was against Zora Folley in 1967). Ali's loss to Spinks in February 1978 was fourteen years to the exact month that it all began for Cassius Clay, when he first became world champion, beating Sonny Liston in February 1964.

As ever though, things moved fast in the life of Muhammad Ali and he was still very much in demand. After the Spinks loss, he flew off to Bangladesh with his wife Veronica on another goodwill mission. The now ex-champion, still sporting a bruised eye from the fight, promised everyone on departure that he would come back to beat Spinks in a return bout, declaring that he would dedicate more time to training and be the first fighter to win the title three times.

'I shall return,' said Ali.

On 15 September 1978, Muhammad fulfilled his promise and did become the first man in the history of heavyweight championship boxing to win the title for the third time, even though in boxing trivia it could be argued that his win against Spinks really made him a four-time champion. Ali's first title win was against Liston in 1964 (1) but the WBA title was stripped from him in June 1964 after granting Liston a rematch. He regained the WBA title against Earnie Terrell in 1967 (2), then further regained the undisputed title again in 1974, after his title was stripped from him in 1967, against George Foreman (3), and then regained the WBA title fighting Spinks in 1978 (4).

The WBC title was not at stake against Spinks, as it had been awarded to Ken Norton (March 1978) after Spinks opted to fight Ali in a return bout rather than face the WBC No. 1 contender. Norton wouldn't hold onto the WBC title for long, as he would lose it in his first defence in a 'fighting-thriller' against the 'Eastern Assassin' Larry Holmes in Las Vegas on 9 June 1978.

Ali's record-breaking win against Spinks in 1978 was memorable in historical terms, as he became three-time champion, but the WBA title bout lacked the exciting see-saw drama and explosive bone-crunching punches that were produced that September night in 1977 against Shavers.

When Sonny Liston had left Newcastle in 1963, 'changes came a ringing' in his very next bout, and he found himself an ex-champion when matched with young Cassius Clay. Fourteen years later, when Ali

himself left Newcastle, his very next bout was found to be the last time he would raise his arms in victory as defending champion. The Shavers bout became his last-ever successful title defence and arguably his last-ever great fight.

Earnie Shavers himself wouldn't fight again until March 1978, when he would lose another points decision, this time to future WBC champion Larry Holmes (Shavers' title bout with Holmes would take place in a return fight at Caesars Palace in September 1979). Incredibly, Shavers would fight on during the '70s, '80s and '90s and wouldn't retire from boxing until 1995. He left with an impressive ring record of eighty-nine fights, seventy-four wins, sixty-eight KOs, fourteen defeats and one draw.

CONCLUSION

Ali's record-breaking world title win in September 1978 grabbed the attention of the world's media and congratulations came from around the globe, from as high as US President Jimmy Carter – one in an estimated billion others who watched the bout on television.

On Tyneside, it was no different, and his win hit the front-page headlines. 'I DID IT! – Ali gets crown back and £1.6 million' was the headline of the *Evening Chronicle* on 16 September 1978.

Afterwards, the world's press, who had sometimes been split upon believing his brash predictions over the years, finally united and admitted that the champion was what he had been telling everyone since the early 1960s – he simply was the Greatest.

Congratulations were sent to the new champion from around the globe and none more so than from the small seaside town of South Shields and the people of Tyneside. Dorothy Gillanders, who wrote a poem for Ali when he surprised everyone in the town on his arrival the previous year, was asked by Cllr Tom Bell to write another that could be personally sent to the boxer to congratulate him on his record-breaking achievement. Dorothy accepted the task and the poem she completed was sent off to America. It went as follows:

> You did it, you did it, we knew that you would.
> You beat him on points then, as only you could
> You taunted him, bugged him, moved round him with glee
> And flew like a butterfly and stung like a bee.
>
> He had no chance really, before he began.
> But to his credit, he stood up to you like a man.

And your footwork, your jabbing, each round that you jinx.
In all, it was too much for poor Mr Spinks.

We folk of South Tyneside are happy and glad.
That we can call you, Ali, our canny lad.
For you took to our hearts, Ali, when you were here.
And you're our gentle giant, brave, bold and sincere.

Your wife and sweet Hana, of you must be proud.
Want to shout from the rooftops to everyone loud.
Our Ali is the Greatest there ever has been.
Our Ali's the Greatest the world has ever seen.

So many congratulations we send to you.
We South Tynesiders, all to name but a few
You hold your head high like a glorious pine.
You will never be forgotten, till the end of time.

> By Dorothy Gillanders, 1978.
> (Reprinted by kind permission of Dorothy and
> Peter Gillanders and the *Shields Gazette*)

Inevitably, as the 1970s neared its close, so did Muhammad's hold on heavyweight boxing titles. It looked promising at first for the champion to leave boxing after his historic triumph over Leon Spinks. The new three-time champion announced to the world that he would only hold onto the title for six months, without defending it, and retire when demands by the WBA were put on him to do so. He said his win against Spinks in 1978 was 'definitely' his last-ever fight and even took part in a world farewell exhibition, arriving in London in May 1979 to start a ten-city European tour where an aging and overweight Ali completed exhibition sparring rounds with British and Commonwealth heavyweight champion John L. Gardner, new pro starter and future world light heavyweight title challenger Lottie Mwale, and promising heavyweight 'Big' Joe Awome.

The champion officially announced his retirement two months later, in July of that year, and his army of fans around the globe were happy to see him leave boxing a winner. However, the lure of the ring and a contracted $8 million pay day eventually brought him back into boxing at the start of the new decade. Sad defeats to Larry Holmes in October 1980 – which incidentally took place exactly twenty years to the month that Clay/Ali

began his professional career (October 1960) – and a later points defeat to Trevor Berbick in 1981 finally convinced Muhammad that his title-winning days lay firmly in the past, and 1981 became his last year as a professional fighter before he retired permanently.

The 1980s saw a new era of heavyweight champions begin, as Larry Holmes established himself as Ali's rightful successor and continued defending the title he won near the end of the previous decade in 1978. However, by 1986, a twenty-year-old boxer smashed his way to the pinnacle of heavyweight boxing and became the youngest-ever world heavyweight champion. His name was 'Iron' Mike Tyson, who wasn't only knocking out most of his opponents, but was also scaring them in the same manner Sonny Liston and George Foreman had done in years gone by. Formidable opponents seemed to be smashed aside with ease as Tyson unified the boxing titles that had become split soon after Ali's loss to Spinks in 1978, and for a while 'Kid Dynamite' was universally recognised as the new king of boxing.

Ali's era of punching people for pay and holding onto the same titles as 'Iron' Mike Tyson was over, but there was always something much bigger on the horizon than mere boxing titles for Muhammad. After his boxing in the ring was over, he said he wanted to dedicate more time to fight for human rights and spread the word of Islam. In retirement, he found the world still loved him and he loved the people of the world. Even in his fighting days, he had become bigger than boxing itself as his talents outside the ring of knocking people over with the power of personality, humility and kindness, rather than the power of his punches, became his everlasting trademark. His time as 'king of Tyneside' is only one small example of doing just that as, in agreeing to Johnny's request, the boxer himself had very little to gain, except for the satisfaction of making others happy.

Despite an announcement in September 1984 that Ali was suffering from Parkinson's syndrome, the ex-champion continued unabated, travelling the globe and repeating the love affair he had with the Geordies with other regions and peoples. Indeed, it is Ali's love for people, his kind spirit and ability to carry on through adversity that eventually led him onto the road of becoming an international icon for peace, justice and equality.

'Love is the net where hearts are caught like fish' is another popular line Muhammad would pen along with his autographed replies to letters from fans around the globe. Those few words may well be described as his real lifetime goal, as he still spends his retirement years travelling to every corner of the world helping the needy and raising millions of dollars for good causes. (In 2013, an Ali Fight Night fundraiser in Phoenix Arizona raised $3 million in one evening for the Ali Parkinson Centre, Barrow Neurological Institute.)

A boy boxer raised on No. 3302 Grand Avenue, Louisville, Kentucky, who, as a young pro, was first viewed as a fun figure, then hated by some in America for defying the draft, later became arguably the most beloved sportsman in history. Who could forget the time he inspired a television audience of billions when his trembling hands held onto the torch to light the flame that started the 1996 Atlanta Olympics. That one moment in time touched the hearts and minds of a new generation of people worldwide; so much so, that Ali's popularity seemed to reach a parallel or, dare I say it, even exceed that of his championship glory days after the Foreman bout in 1974.

Throughout his life, Muhammad would go on to win many other coveted awards and titles, such as Sportsman of the Century from *Sports Illustrated*, BBC's Sports Personality of the Century and, in 2005, he gained the highest civilian award that America can bestow on anyone, this being the Presidential Freedom Medal, which was presented to him by US President George Bush at the White House. However, there is another title, one that stands above all the rest and which is more symbolic to the reciprocal love Muhammad Ali traded with people around the globe.

Even though he may have lost his presented plaque over time, the words engraved on it still cling onto the man they call the Greatest. The title I am talking about was bestowed on him way back in 1973, by his friend, Irishman Paddy Monaghan. Paddy presented Ali with the plaque shortly after his defeat to Ken Norton, on behalf of his worldwide fans and followers. On the plaque, the words simply read 'The People's Champion – Muhammad Ali'.

Those few engraved words on the plaque really sum up the person best of all, as it was in the hearts of the people, of not only Tyneside but the world over, that Muhammad Ali truly triumphed. We all remained under his spell, as Muhammad Ali, the 'People's Champion', is the undisputed, undefeated and 'Greatest' champion of all time.

Postscript

Thirty-six years after Muhammad and Veronica Ali had their wedding blessed in South Shields, their oldest daughter, Hana, was married herself in Los Angeles, California, in November 2013. South Shields resident Tina Gharavi received the privilege of a personal invitation to attend Hana's biggest day. Congratulations Hana.

MUHAMMAD ALI CENTER
Be Great :: Do Great Things

alicenter.org

OUR SUPPORTERS ARE THE GREATEST!

BECOME A MEMBER
Be part of a membership program that invites people from all over the world to be great and do great things!

A membership to the Muhammad Ali Center provides you with:
Free admission to the Center :: Discounts in the Muhammad Ali Center Store
Quarterly e-newsletter :: Advance notice of Ali Center events throughout the year :: Plus Much More!
To learn more about becoming a Member, visit alicenter.org/memberships.

SECOND ANNUAL MUHAMMAD ALI HUMANITARIAN AWARDS
The Muhammad Ali Humanitarian Awards presented by the Yum! Brands Foundation, taking place Fall 2014, celebrates the greatness of people around the world who are making differences in their communities and beyond.
To learn more about the Muhammad Ali Humanitarian Awards, visit alicenter.org/awards.

GENERATION ALI
Inspired by the principles and the legacy of Muhammad Ali, Generation Ali represents a series of initiatives grounded in an interconnected social platform that encourages young people to find their personal "greatness" through service to others.
To learn more about Generation Ali, visit alicenter.org/generation-ali.